IMAGES
of America
CORDOVA

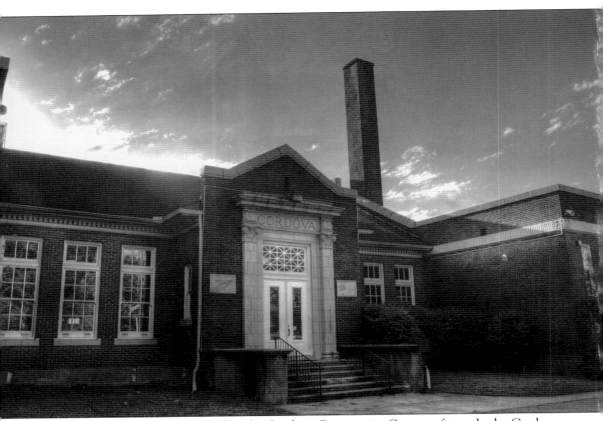

The Cordova Museum is located in the Cordova Community Center—formerly the Cordova School building—erected in 1913. On July 28, 1995, the building was listed in the National Register of Historic Places. This pictorial history book is published by the museum's directors in celebration of the building's 100th birthday. The mission of Cordova Museum is to collect and preserve the town's history as well as to document and preserve the lineage of the early settlers. It is the museum's goal to promote community bonding and appreciation of local history among established residents, newcomers, and visitors to Cordova. Admission is free. (Courtesy of Becky Stillions.)

ON THE COVER: This Cordova picnic was held between approximately 1908 and 1910. During the days without telephones, church, school, and community picnics gave young people opportunities to get to know one another, as some farms were several miles apart. At a Cordova picnic similar to this, Fred Hooker and Ruby Bryan were married by Squire Walter Granville Allen on August 10, 1910. (Courtesy of Nancy McDaniel.)

IMAGES
of America
CORDOVA

Darlene Sawyer
Darlene Hooker Sawyer
and Dr. Jane Howles Hooker
Jane R Hooker

ARCADIA
PUBLISHING

Published by Arcadia Publishing
Charleston, South Carolina

Printed in the United States of America

Library of Congress Control Number: 2012955490

For all general information, please contact Arcadia Publishing:
Telephone 843-853-2070
Fax 843-853-0044
E-mail sales@arcadiapublishing.com
For customer service and orders:
Toll-Free 1-888-313-2665

Visit us on the Internet at www.arcadiapublishing.com

"The heart that truly loves never forgets!"
—*Old Proverb*

CONTENTS

ACKNOWLEDGMENTS

We would like to thank each person who submitted a photograph for this book. Thank you for allowing us to publish your family photographs in order to document a small portion of Cordova's history. We would especially like to mention Donnie Hugh Odom for his volunteer service and assistance in scanning and organizing photographs, for his willingness to help in whatever capacity was needed, and for his generous donation of new computers, which helped us immensely with preparation of this book and with the ongoing assistance in cataloging museum archives. We would also like to thank John Lawrence Garrison Jr. for assisting in the gathering of historic information, documenting his recollections of early families, drawing maps and diagrams, collecting photographs, writing captions, promoting this project in the community, and for displaying random acts of kindness such as bringing in snacks while we worked. Jane Moore Burrows and Norma Schwam Miles sent in envelopes of photographs almost weekly and included many notes to help with our task of writing captions and documenting historic information. Three local businesses donated goods or services that helped with this project: Brother International Corporation donated an MFC J825DW all-in-one printer, Cartridge World donated ink refills, and Dr. Jason Botts of Botts Dental Spa donated an HP CM2320NF multifunction printer that we have put to good use. To those mentioned and many others, we sincerely thank you for your help and support.

INTRODUCTION

Beginning February 25, 1826, the Tennessee General Assembly passed the first of a series of Occupant Entry Laws allowing West Tennessee settlers to claim land. Individuals also secured land through service in the Revolutionary War or War of 1812, by procuring land grants, or by laying claim to land that was not yet on sale. Some say that one's tract of land was defined by riding as far as possible in a square shape over the course of one day. These acts facilitated the settlement of Shelby County, Tennessee, where the first form of internal government was militia districts that, in 1834 and 1835, became civil districts. When all of this occurred, pioneers from the east flooded these new lands.

The majority of settlers in the Ninth Civil District in the 1830s came by wagon train from North Carolina and Virginia. They were seeking free, or cheap, plentiful lands in the hope of making a better life. In 1833, Robert Ecklin came to Cordova, Tennessee, and bought 1,000 acres for $500. On April 1, 1835, he brought a caravan from Beaufort County, North Carolina, and settled on the Macon-Hall Roads, naming his plantation Woodland. His brother Joshua Ecklin Jr., Thomas and Elizabeth "Betsy" Ecklin Allen, and William and Subrina Ecklin Patrick were included in this first caravan of 30 wagons. In 1837, Robert returned to North Carolina again to bring back other family members and friends. Other pioneers headed to West Tennessee from Virginia, including the William Quarles Pleasants wagon train that originated in Louisa County, Virginia, and arrived in nearby southwest Fayette County in 1835.

Soon, other North Carolina and Virginia families followed, and many claimed hundreds or thousands of acres. It was imperative for survival to clear the land and plant crops as soon as possible. They then built temporary log shelters and later erected meetinghouses and churches, permanent homes, and schools. They raised cotton, vegetables, wheat, tobacco, and livestock. Three tragic events affected the progress of the early settlers—the Civil War, the yellow fever epidemics of 1873 and 1878, and the swine flu epidemics in 1898 and 1920.

Early churches played an important part in the development of Cordova. Services were held in homes for years and were then moved to meetinghouses. Several denominations—Baptist, Presbyterian, Cumberland Presbyterian, and Christian—formed union churches with every-fourth-Sunday preaching arrangements until separate structures could be built. Some of the early churches were Green Bottom, Morning Sun Cumberland Presbyterian, New Hope Baptist, Cordova Baptist, Cordova Presbyterian, Bethany Christian, and early African American churches Pisgah Baptist, Morning Grove, and Morning Chapel.

The Cordova area was first called Marysville in 1860 after the neighborly widow Mary Williams; no earlier name for the town has been documented. By 1875, the town was named Allentown because of the number of Allens living there, such as James Watson "Jim" Allen, whose business, the area's first general merchandise store, was located on the south side of Macon, the present-day business district. Jim Allen donated land to build the school, the Presbyterian church, and a community cemetery, and also donated lots for both the Baptist and Presbyterian parsonages.

The first school building, also used for Sunday school, was located on Sanga Road just north of Fay Road, facing east, near the corner of Rocky Point. The first schoolteacher, around 1880, was Augusta "Gussie" Allen (the wife of Squire Walter Granville Allen). It was said that she was well liked by the students. The second teacher was Thomas "Tom" Yates, who lost an arm in the Civil War and was said to be a strict disciplinarian. In 1890, after the first school burned, a second school was built on the property donated by Jim Allen a short distance to the northwest to accommodate the growing number of students. This building also burned and was rebuilt in 1904; it later became the custodian's home when the large brick Cordova schoolhouse was erected on the same property in 1913.

Prior to 1870, most African American children in the rural Cordova area were educated on the plantation, in the home, or at church. Their first organized education took place in Augusta Rosenwald Schools located on Sanga Road, Hall Road (Houston-Levee), and Raleigh-LaGrange at Bethany. Then, around the 1950s, the Shelby County Board of Education built Mount Pisgah School.

In 1888, the Midland Railroad came through and named the town Dexter. As the railway expanded through Kentucky, however, it went through another town named Dexter, which caused confusion with the mail. The railroad requested that the town propose another name, and it is said that Roscoe Feild from the nearby Mount Airy Plantation suggested the name Cordova. Roscoe, a Princeton University graduate, had left in 1849 to mine gold in Cordova, California.

Many young men volunteered to serve the country during World War I. From 1941 to 1945, more young men were drafted to fight in World War II. Most every home had at least one family member enlisted. Several from Cordova and surrounding areas were wounded or did not come home at all. The National Fireworks plant was the first industry located here, producing 20-millimeter shells, 40-millimeter shells, smoke pots, and incendiary bombs for the Army and Navy. This munitions plant provided many jobs for a town of predominately farmers and won five awards of excellence.

In the 1940s and 1950s, several of the farmers grew flowers. At one time, 92 percent of the fresh flowers sold in Memphis came from Cordova. Most were sold at the Curb Market at Crosstown or to individual merchants. The town's appropriate slogan—Farms, Flowers, Fellowship—was displayed on a sign erected in the park near the Baptist church.

Cordova School was integrated around 1967 and closed in 1973. The building was used for storage by Shelby County for the following 12 years until a For Sale sign was posted; the community purchased the building for $150,000 in 1985. Former classmates meet here for class reunions, and newly formed churches have used the building as a temporary church. Athletic teams use the gymnasium, and social events are held in other rooms for special occasions. The Cordova Museum has been housed in this Cordova Community Center since 1986. The two-day Cordova Festival draws the community together again at the close of the summer. An open house is being planned for all former students and the Cordova community to celebrate the 100th birthday of the old Cordova School building on August 10, 2013.

Cordova is located in the eastern portion of Shelby County, approximately 18 miles from downtown Memphis. A petition to incorporate the Old Cordova area of 20.4 miles was defeated in 1979. On July 4, 1990, parts of it were annexed by the city of Memphis, and more annexations occurred in 2012.

Approximately 14 or more streets in the Cordova area are named after the early settlers, including Rogers, Cully, Magilbra, Lurry, Allentown, Bazemore, Farley, Humphreys, Clinton Way, Yates, Lenow, Reid-Hooker, and Redditt. Several descendants of the early settlers are still living in the community, holding tight to their rural roots and preserving the local history.

One

EARLY CORDOVA FAMILIES AND HOMES

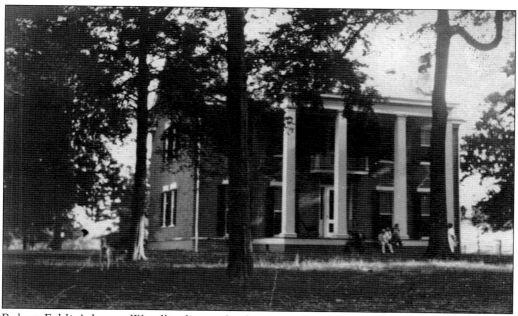

Robert Ecklin's home, Woodland, was the first brick home in this area. It was designed by architect Ace Edwards and constructed in 1835. The home's name changed several times. Robert's granddaughter Marietta Crenshaw Justice called it Wildwood, and Dr. James Minor later purchased it and named it Minor Place. Arthur Halle designated it the Hollys, and business owners operated it as the Holly Hills Country Club, Woodland Hills Country Club, and, presently, the Woodland Hills Event Center. (Courtesy of Margaret Brooks.)

Robert Ecklin came to Tennessee from Beaufort, North Carolina, in 1833. For $500, he bought 1,000 acres of good farmland in Cordova on Macon Road at Hall Road (Houston Levee). In 1835, he brought a caravan of 30 wagons, which included his brother Joshua Ecklin Jr., William Patrick, and their wives and friends. Additionally, they brought seeds, pine trees, plows, animals, and a primitive cotton gin. Upon arriving in April, they cleared and plowed the land for spring planting, imperative for their survival in this wilderness. Temporary log shelters were built, and construction on the main house, Woodland, began. The home was designed by Ace Edwards, the brother of Robert's future wife. Thomas L. Allen bought the adjacent land and married Robert's sister Subrina. Joshua Jr., Robert's brother, built his home across the road. Robert married Lucinda Edwards from nearby Hickory Wythe in 1840, and his children would marry into the neighboring families of Allen, Crenshaw, and Feild. (Courtesy of Margaret Brooks.)

William Henry Allen and Joseph Bryan Patrick were first cousins. William was the son of Thomas L. Allen Sr. and Elizabeth "Betsy" Ecklin Allen. The Allen family settled south of what is presently the Macon and Berryhill Road area. Joseph was the son of William Worsley Patrick and Subrina Ecklin Patrick. The Patricks settled on Lenow Road, known as the Morning Sun area. Nine generations later, Patrick descendants still live there. (Courtesy of Cordova Museum.)

John Henry Hobart Patrick and his wife, Elizabeth Morton Houston Patrick, are surrounded by their children and grandchildren. A farmer and carpenter, he was a first cousin of William Allen and Joseph Patrick. She was a widow when they married. The Patricks were faithful members of the Morning Sun Cumberland Presbyterian Church, serving as elders, Sunday school teachers, and cemetery caretakers. (Courtesy of Mary Patrick Smith.)

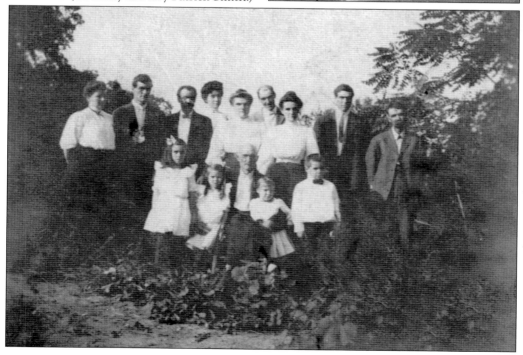

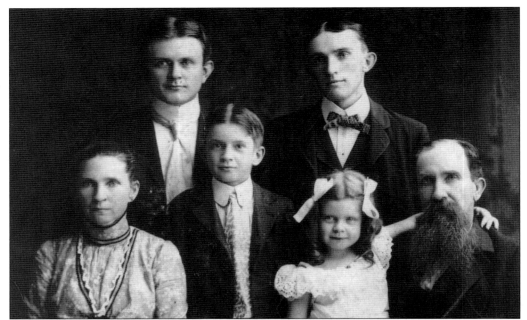

Jamesey Allen (front left), the daughter of Thomas and Betsy Ecklin Allen, married Thomas Varden Yates (front right). Their son, Thomas Walter Yates (back right), lost an arm in the Civil War and became the second schoolteacher of Cordova, succeeding Gussie Allen. (Courtesy of Jane Moore Burrows.)

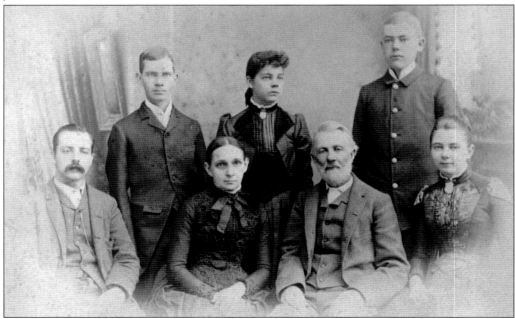

Roscoe Feild is seen with his wife and children. From left to right are (first row) Hume Feild, Emily Feild (Roscoe's wife), Roscoe Feild Sr., and Charl Feild; (second row) Robert Feild, Ellen Feild, and Roscoe Feild Jr. Roscoe Sr. studied law and graduated from Princeton University. He suggested the name Cordova when the railroad requested a new town name to replace Dexter. (Courtesy of John Feild.)

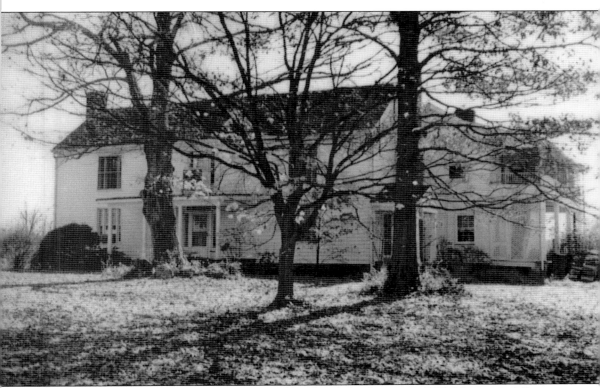

Roscoe Gano Feild inherited 1,300 acres of land and this house in 1855. He married Emma Augusta "Emily" Ecklin in 1861 and added an L-shaped addition to the structure. This home and grounds were typical of early self-sufficient plantations. Firewood, vegetables, grains, and fruits were plentiful, as were hogs, chickens, and beef cattle. A blacksmith shop and primitive gin were in operation. Emily named the home Mount Airy, and it remains in the Feild family today. Mount Airy was listed in the National Register of Historic Places on February 14, 2002. (Courtesy of Cordova Museum.)

William Joseph Strong (1819–1876), seen at left, married Mary Angeline Baxter (1821–1900), seen below. Some of their children married into other prominent Cordova families—Sarah Strong married John Sanderson Harrell, Margaret Jane Strong married William Marshall Lurry, George Madison Strong married Sarah Kirk, William Newton Strong married Georgia Ella Hamner, and Annie Eliza Strong married Walter C. Hamner. (Both courtesy of Harold James.)

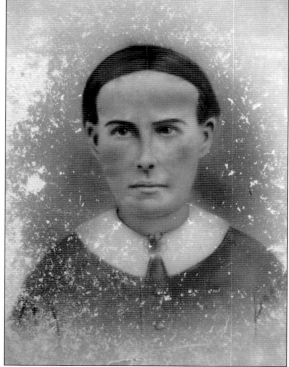

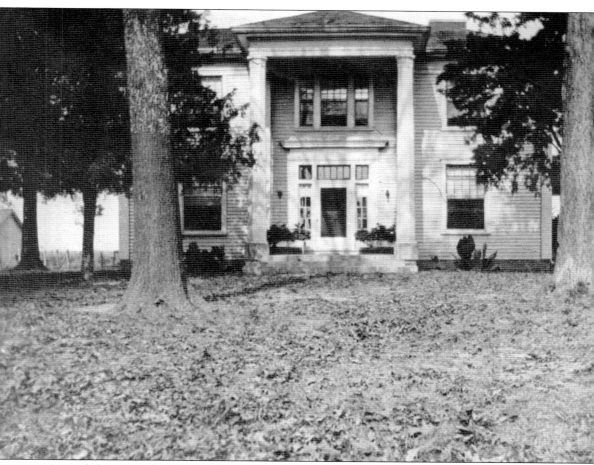

Around the time of the Civil War, James Abernathy Creath owned about 1,500 acres of land where the Evangelical Christian School sits on Macon Road across Germantown Parkway. After Creath's death, the manager of the land, James Goodlett, purchased the property and assigned John Henry Schwam to oversee it. Years later, Creath's son Joseph Henry Creath purchased this home and 1,400 acres. He remodeled the structure with modern conveniences, but ill health led him to sell the home and farm in 1920. The property changed owners several times through the years and for a while belonged to Edward Humphreys, who at one time was said to be the largest landowner in Shelby County. (Courtesy of Charles Creath Cottam.)

Joseph Henry Creath was born on October 3, 1867, in Cordova, the second child of James Abernathy Creath and Martha Rogers Amonet Creath. He married Mary Elizabeth Allen, daughter of James Watson Allen and Mary Elizabeth "Bettie" Roach. Creath served two terms as Shelby County trustee. (Courtesy of Charles Creath Cottam.)

William Henry "Billy" Yates (1841–1934) was the son of Thomas Varden Yates and Jamesey Allen and the grandson of early settlers Thomas Allen and Elizabeth "Betsy" Ecklin. He was the last person buried in the Allen Yates family cemetery on his grandfather's property. His grandfather, Thomas Allen, was the first interred there. (Courtesy of Linda Yates.)

James Watson "Jim" Allen owned the first-known store in this area, the J.W. Allen Store. He donated land to build a school, a cemetery, a Presbyterian church, and the Baptist and Presbyterian parsonages. His store was later purchased and run by Walter Granville Allen. Because of the many Allens who lived here, the town was named Allentown in 1875. (Courtesy of Cordova Museum.)

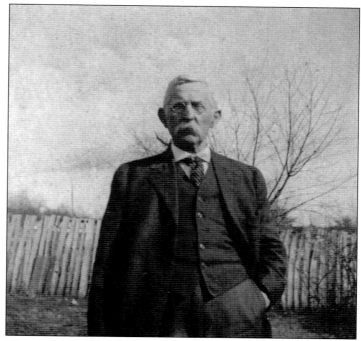

Etta Allen (center) was the first postmistress of Cordova. When she was five years old, her mother died. She was taken in and raised by her uncle Jim Allen and his wife, Betty Roach Allen, who had small children of their own. Etta's father, Walter Clopton Allen Jr., was Jim's brother. Standing to the right is Jim's daughter Nannie Allen Humphreys, who married widower Joseph Ezekiel Humphreys (left) and helped to raise nine stepchildren. (Courtesy of Cordova Museum.)

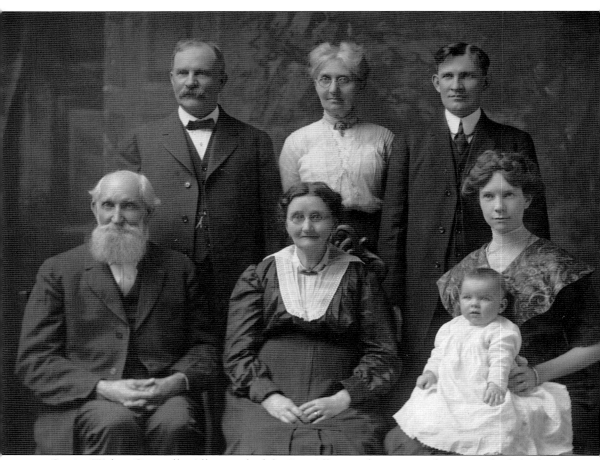

Squire Walter Granville Allen worked for Jim Allen in the mercantile store, which he later purchased. He also ran a sawmill and a gin, was president of Cordova Bank & Trust Company, and was a member of the Shelby County clerk's office. In this photograph are, from left to right, (first row) his uncle Thomas Allen Jr., aunt Roxana Rogers Allen, and daughter Marie Allen Hooper holding his granddaughter Augusta Sue Hooper; (second row) Walter Granville Allen, wife (and cousin) Alice Augusta Allen Allen, and son-in-law Dr. Elroy Levert Hooper. (Courtesy of Margaret Brooks.)

Walter Maxwell Allen (1886–1920) was the son of Walter Granville Allen and Alice Augusta "Gussie" Allen. He died at age 36 of a gunshot wound to the heart. He was a merchant and was married to Elizabeth Thurman Allen, daughter of John Royster Allen and Jennie Reed. (Courtesy of Margaret Brooks.)

The Walter Granville Allen family poses in front of the Allen home on Macon and Dexter. Its members are, from left to right, (first row) James Stewart Ingram, Theresa Allen Ingram, Augusta Sue Hooper, Roxanna Rogers Allen (wife of Thomas Allen, mother of Gussie), Bob Watt Allen Trask, Thomas Allen (father of Gussie, husband of Roxanna), and Dr. Elroy Levert Hooper (husband of Virginia); (second row) Irene Cole Allen, William Thomas Allen, Walter Maxwell Allen, Alice Augusta "Gussie" Allen, Walter Granville Allen, and Marie "Virginia" Allen Hooper (Courtesy of Margaret Brooks.)

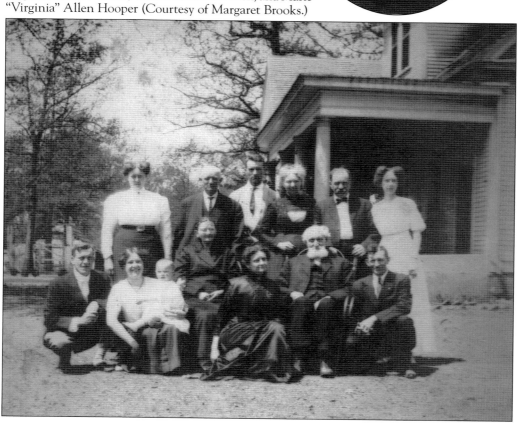

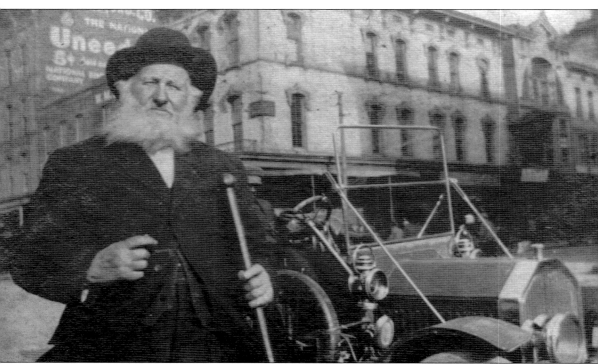

Jasper Clinton Rogers (1835–1914) was a cotton farmer. He pestered the people at the Cotton Exchange to give him a ride in this car in the days before automobiles were readily available. By horse and wagon, it took Jasper four days—two each way—to take his cotton to Memphis to sell. After Jasper's daughter was involved in a failed courtship with a neighbor's son, Jasper got a stick (perhaps the one pictured here) and drew out a new route to avoid passing the neighbor's property; this path later became part of the present Macon Road offset. When the railroad came to Cordova and crossed through Jasper's property, he put up gates to make the train, only four or five boxcars in length, come to a complete stop. The engineer had to open the gate, and the conductor had to shut it. Jasper did not want the train frightening or killing his livestock. He was the son of William Cullen Rogers and Sarah Jernigan Rogers, who came to Cordova from Haywood County, North Carolina, in 1838. He married Sarah Elizabeth "Betty" Yates. (Courtesy of Carolyn Bazemore.)

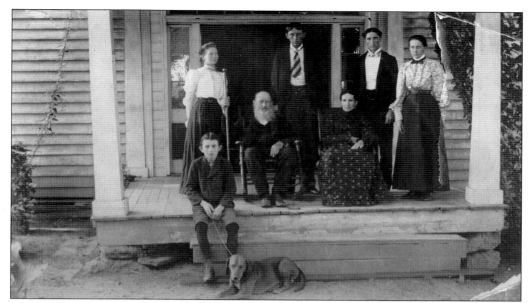

Jasper Rogers and Elizabeth "Betty" Yates Rogers are pictured sitting with their children on the front steps of their Cordova home. Charles is holding the dog's leash, and Jasper and Betty are sitting in their rockers. Standing are, from left to right, Linnie Mae, Claud Buster, Clarence, and Gertrude. Claud and Clarence were twins. (Courtesy of Carolyn Bazemore.)

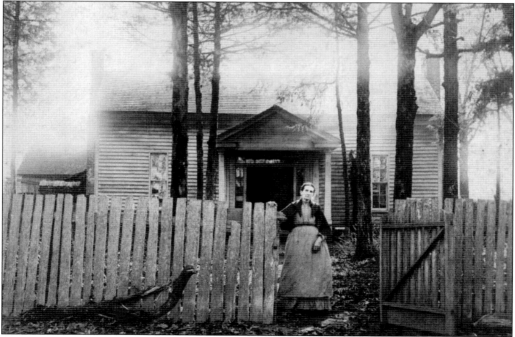

Elizabeth "Betty" Yates Rogers, the wife of Jasper Clinton Rogers, is seen standing outside her home in Cordova. She and Jasper had eight children, only five of whom lived to be adults; the other three died young of a stomach virus. Betty was the daughter of Thomas Yates and Jamesey Allen Yates. (Courtesy of Jane Moore Burrows.)

Dr. Clarence Augusta Rogers, born in 1878 to Jasper Rogers and Elizabeth "Betty" Yates Rogers, studied at Vanderbilt University for his medical degree. He was the twin of Claud Buster Rogers. (Courtesy of Carolyn Bazemore.)

Milton Andrew Nichols helped build the Midland Railroad in Cordova. He and wife Amanda Stone Nichols settled at 395 Rocky Point Road in Cordova in 1885. Amanda's sister Laura Stone lived with them. They attended the Cordova Presbyterian Church. (Courtesy of Elizabeth Virginia Nichols Griffin.)

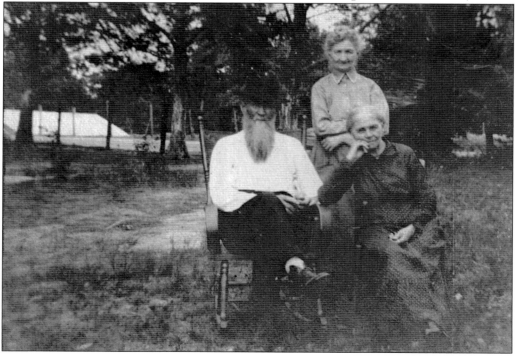

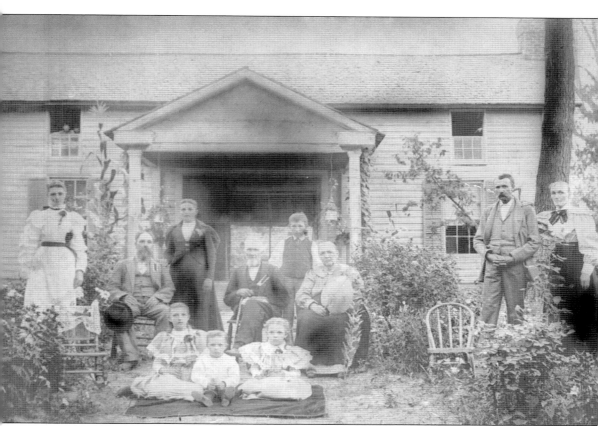

James Gillespie Houston (1820–1899) was born in Blount County, Tennessee. In 1848, he married Elizabeth Jane Davis, daughter of Alexander and Martha Houston Davis, and they went on to have six children. Their house was built in the mid-1800s, just before the Civil War. Because it sat on the bluff just north of the Wolf River, it was called Houston Hill. This could be why this section of old Houston Levee Road is now called Houston Hill Road. At least five generations of the family were born in this house. The Houstons married into the Humphreys, Williams, and McNeely families. In later years, the home belonged to the Houstons' great-grandson Lester Stanton James, who married Doris Strong, daughter of William Joseph Strong and Edna Humphreys Strong. A descendant still owns the property today. Pictured here from left to right are (first row) Betty, Alva, and Alma Houston; (second row) Ella Dora Houston, John and Pearl Houston, James G. Houston, Robert Williams, Elizabeth Jane Davies Houston, and Joe and Molly Houston McNeely. (Courtesy of Rita James.)

The old Carter home was a simple log cabin that sat on the property at the corner of present Sanga and Walnut Grove Roads, owned by Braxton and Julia Owen Carter. When a later addition to the home was built, clapboards were placed over the original logs, as seen here. The Carters were early members of the New Hope Baptist Church. (Courtesy of John Edward Pierce Jr.)

The Austin Baker family purchased the Crenshaw farm at the corner of Berryhill and Macon Roads in 1950. This photograph shows the Crenshaw log cabin that was part of this original dogtrot home that had already been covered over at the time the Bakers purchased the property. Located at this site were a dairy barn, feed-and-tack barn, garage, well house, main house, and large barn. (Courtesy of Yvonne Baker.)

Above is the home of John Hamilton Burrows in the Bethany community where all of his children, with the exception of Mary Elizabeth Burrows Taylor, were born. His children were Mamie Gertrude, born 1890; Milton Dorris, born 1892; Oscar Grady, born 1894; Sidney Elder, born 1897; John Talmage, born 1899; and Mary Elizabeth, born 1902. The John Burrows family later moved to the home on Rocky Point Road pictured below. (Courtesy of Jane Moore Burrows.)

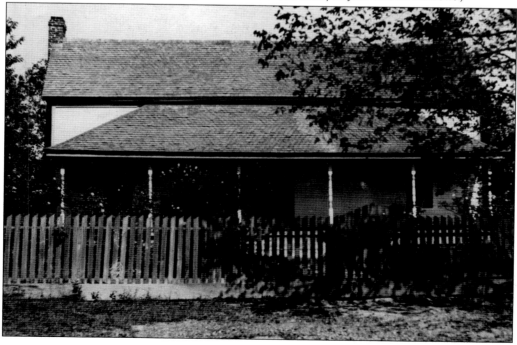

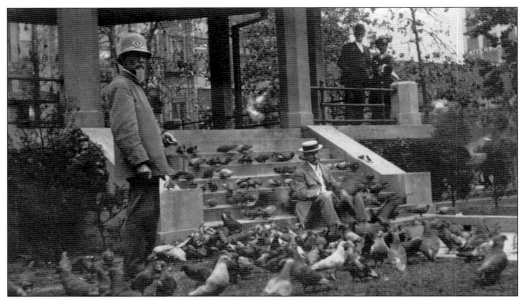

Thomas Wilson Lurry Jr. (1849–1924), caretaker of Court Square in downtown Memphis, is seen here feeding pigeons. Tom married Mary Frances Wilson and had 13 children. This photograph was taken in 1918. (Courtesy of Carolyn Bazemore.)

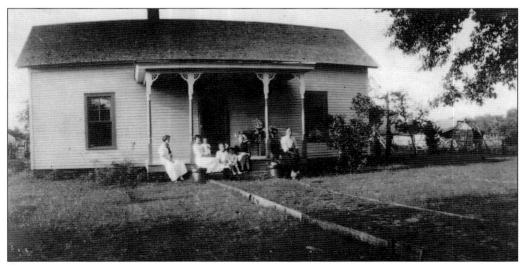

This was the home of Mary Williams. The town was originally named Marysville after her in 1860. This home, located at 8556 Macon Road, was later occupied by the Lurry family. It became the location of the Mozelle Reid Farley home in 1941. (Courtesy of Cordova Museum.)

Christopher Columbus Owen was born in 1833 in Alabama and moved to Cordova with his family before 1840. His three children were Tennessee Virginia Owen, who married John Wesley Carter; John Edward Owen, who married Pearl Yates; and Sarah Owen, who married Jesse Edward Bazemore. These families were early members of New Hope Baptist Church on Sanga Road. (Courtesy of John Edward Pierce Jr.)

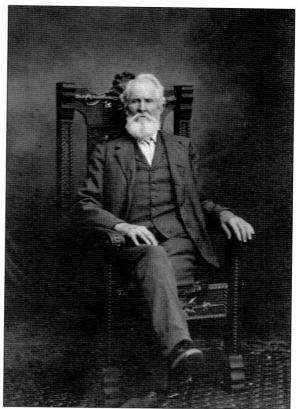

Pictured here are the wife, daughter, granddaughter, and great-grandson of Christopher Columbus Owen. Little John Edward Pierce Sr. stands next to his great-grandmother Mary Elizabeth Wiles Owen. Standing behind him is his mother, Lottie Leola Carter Pierce, and to the right is his grandmother Tennessee Virginia Owen Carter. (Courtesy of John Edward Pierce Jr.)

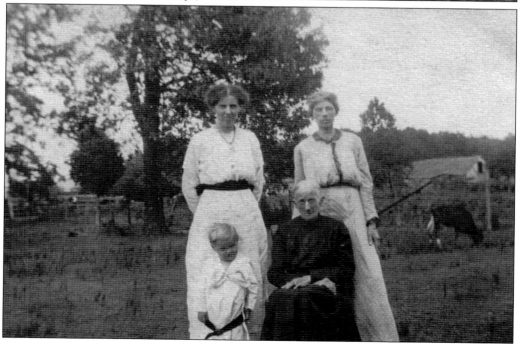

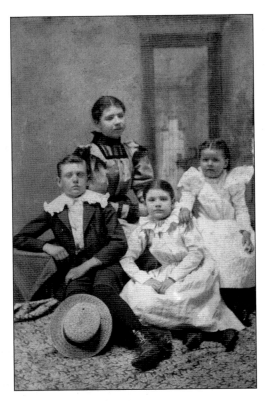

Joe Arrington sits with his cousins Lu Ella Yarbrough, Bettie Leolla Yarbrough, and Effie Mai Yarbrough around 1898. The Arrington and Yarbrough families both owned and operated early stores in Cordova. (Courtesy of Nancy McDaniel.)

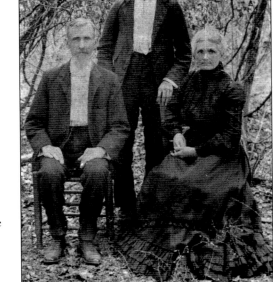

Henry Clay Arrington and wife Betty Locke Arrington are sitting in front of their son Joe. The Arringtons were early store owners in Cordova, and Joe's grandfather Franklin Locke was an early minister of Bethany Church. (Courtesy of Nancy McDaniel.)

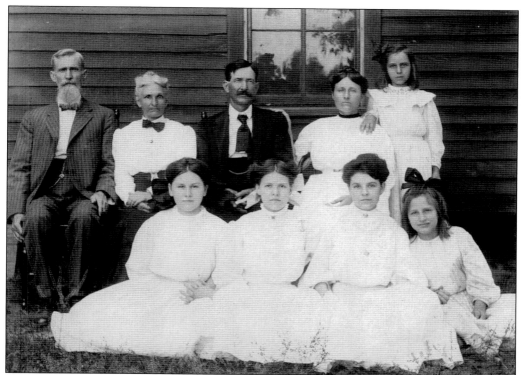

Pictured here are, from left to right, (first row) unidentified, Bettie Leolla Yarbrough, Effie Mai Yarbrough, and unidentified; (second row) Henry Clay and Betty Locke Arrington, William David and Sarah Locke Yarbrough (the sister of Betty), and unidentified. (Courtesy of Nancy McDaniel.)

William Rush Redditt Sr. was the son of Greenberry Redditt and Phinie Wyatt West Redditt. His first wife, Eunice Leona Pleasants, died from complications during the birth of their son William Rush Redditt Jr. in 1917. Rush married Louise Harris and had two more children, Lillian and Louise. The Redditts were early Cordova settlers of the Sanga area. They have their own family cemetery on Walnut Grove, where most of the family is buried. (Courtesy of Annette Redditt Carroll.)

William Newton Strong (1854–1941) is pictured with his wife, Ora, and children. Ora Hart was William's second wife; his first, Georgia Ella Hamner, died young. Pictured are, from left to right, Blanche, William, Ora, Gertrude, and Turley Strong. (Courtesy of Harold James.)

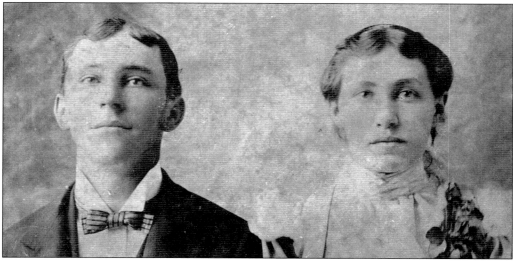

Benjamin Robert Hall and Louella Bazemore Hall, daughter of Jesse Edward and Susan Templeton Bazemore, were married in 1899. They had five children: Oscar Robert, William "Terrell," Sidney Elbert, Benjamin Douglas, and Mary Elizabeth. Louella died at age 47, and Terrell dropped out of school to help support the family by working at the Shelby County Penal Farm. Mary Elizabeth, who was only three when her mother died, was then reared by her uncle Jesse Bazemore's family. (Courtesy of Jo Hall.)

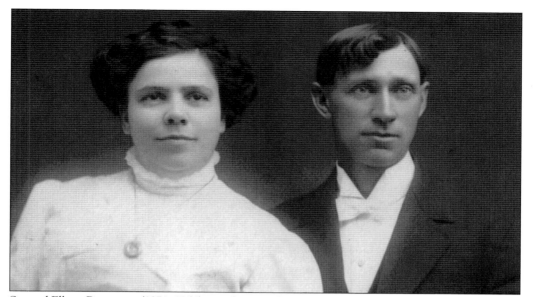

Samuel Elbert Bazemore (1871–1954) was the son of Jesse Edward and Susan Templeton Bazemore from Bertie, North Carolina. He married Lela Belle Humphreys, and they had a farm on Sanga Road. Samuel farmed, and Lela was a schoolteacher. Even after they moved to Cordova proper, they went back and forth to tend the farm on Sanga. (Courtesy of David Bazemore.)

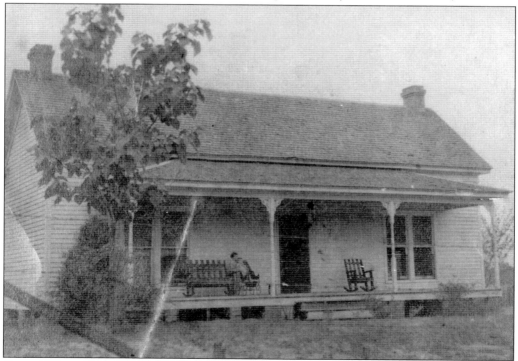

Samuel Elbert Bazemore and Lela Belle Humphreys Bazemore lived in this home on the land they farmed in the Sanga community. They later moved to the old-town section of Cordova on Macon Road in 1918. (Courtesy of David Bazemore.)

Constable John James Carter (at left) lived at the corner of Macon and Sanga Roads. The son of Peyton Carter and grandson of Braxton Carter, he married Minnie Belle Bazemore (below), daughter of Jesse Edward and Susan Templeton Bazemore. He was constable for the Ninth Civil District. (Both courtesy of Mary Louise Nazor.)

Jesse Edward Bazemore (1869–1949) was known to many as "Uncle Ed." He was a lifelong resident of Cordova and a deacon at the Cordova Baptist Church for approximately 40 years. He is buried beside his wife, Sarah Owen Bazemore, in Sangie Cemetery. They were early members of the New Hope Baptist Church. He was the son of Jesse Elbert and Susan Templeton Bazemore. (Courtesy of Jo Hall.)

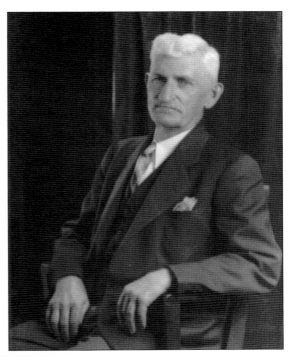

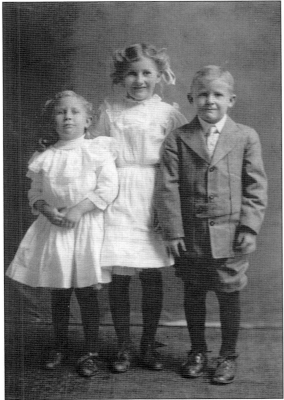

Pictured here from left to right are Susie Mae, Ruby Lillian, and Marvin Christopher, the children of Jesse Edward Bazemore and Sarah Owen Bazemore. Susie Mae Bazemore married James Monroe Reinbold and taught school at Cordova. Lillian Bazemore, who never married, was an early postmistress, and Marvin married schoolteacher Mary Rogers Bazemore. (Courtesy of Jo Hall.)

Mary Eula "Mamie" Boyd (1881–1947), pictured at left, married Arthur Rosalind Patrick on December 19, 1899, at Morning Sun Church, where their families have continued membership for over a century. Arthur Patrick was a carpenter and ran a cotton gin in Fisherville. Mamie's grandfather, Squire William Wash, owned and operated a store and tavern at the corner of Seed Tick and Stage Roads; his business also housed the first Morning Sun Post Office. His wife, Harriet Guerrant Wash, is credited with naming the establishment "the Morning Sun," thus originating the name of the community. Below, Elizabeth "Bessie" Lenow Patrick, daughter of Mamie and Arthur Patrick, was born in 1903. She was part of the Cordova School's graduating class of 1921 and later became the school's secretary. Bessie's middle name came from Capt. John Lenow, who married her great-aunt Mary "Mollie" Guerrant Wash. (Both courtesy of Mary Patrick Smith.)

Dr. Greene Fort Pinkston was born in 1875 in Forest, Mississippi. He began medical school at 24 and graduated from Meharry Medical School in 1904. He was the only African American doctor to practice in the Cordova area. In 1913, after practicing medicine in Memphis for eight years, he moved to Cordova and purchased a 257-acre farm on Lenow Road. He married Penella B. Horne of Brunswick, Tennessee, in 1914. Doctor Pinkston combined farming with his medical practice. Through eminent domain, the Tennessee Valley Authority (TVA) purchased 188.66 acres of his property in 1963. Pinkston died that year at 88. (Courtesy of Howard and Joyce Pinkston.)

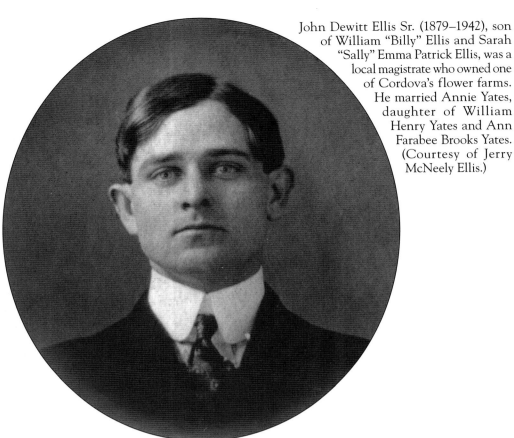

John Dewitt Ellis Sr. (1879–1942), son of William "Billy" Ellis and Sarah "Sally" Emma Patrick Ellis, was a local magistrate who owned one of Cordova's flower farms. He married Annie Yates, daughter of William Henry Yates and Ann Farabee Brooks Yates. (Courtesy of Jerry McNeely Ellis.)

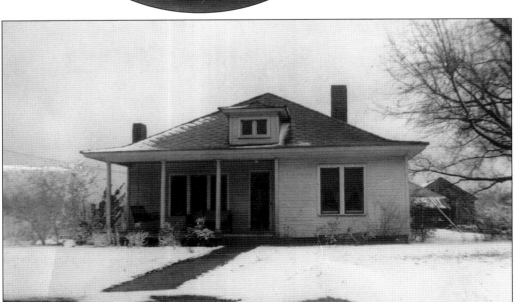

The home of John Dewitt Ellis Sr. and Annie Yates Ellis was located at Rocky Point Road. (Courtesy of Barry and Mary Rogers.)

Clyde Allen Yates (1882–1954) was a truck farmer and school bus driver. He and his wife, Chloe, sold items at the Curb Market in Memphis. He drove the first motorized school bus with benches and sideboards. He once used the school bus to haul pigs, but the incident was not repeated as the children complained about the smell. (Courtesy of Linda Yates.)

Chloe Belle Rutledge Yates (1886–1969) lived in the Bethany community and attended Bethany Christian Church with her parents, David Franklin and Alice Lenora Turner Rutledge. She married Clyde Allen Yates, Cordova School bus driver and truck farmer, in 1908. Their sons Henry Matthew ("Jack") and Peter ("Paul") were also Cordova School bus drivers. Chloe was known for her good cooking on an old wood stove. She fed the farm workers, too. (Courtesy of Linda Yates.)

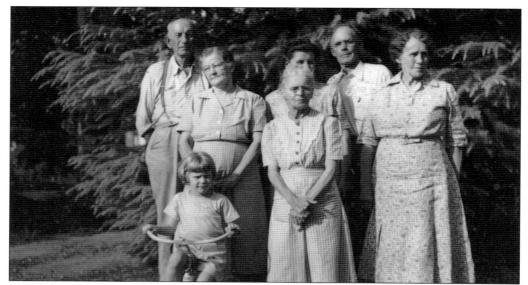

At the far left, Claud and Carrie Lurry Rogers stand behind granddaughter Carolyn Bazemore. Beside Carolyn is Etta Allen, the first postmistress. Behind Allen are Margaret and Jim Bob Lurry, on a visit from California, and to the far right is Ora Lurry. The Lurrys were the children of Thomas Wilson Lurry. (Courtesy of Cordova Museum.)

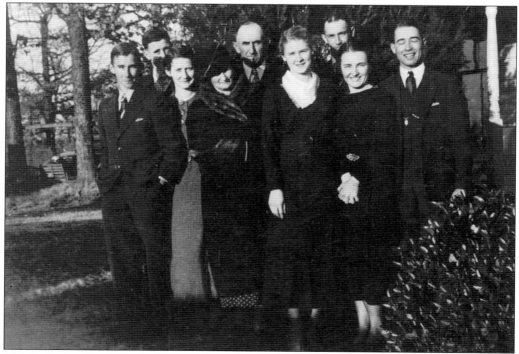

This is the family of Charles Rogers, photographed in 1935. The members are, from left to right, Keith, Wesley, Virginia, Cassie, Charles, Louise, Malcolm, Mary (wife of Leonard), and Leonard Rogers. Leonard would go on to serve as mayor of Knoxville, Tennessee, in the early 1960s. (Courtesy of Jane Moore Burrows.)

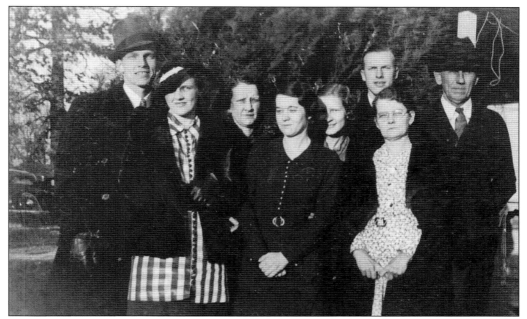

Pictured here are, from left to right, Joseph Rogers, Joseph's wife Adele Rogers, Mary Rogers Bazemore, Ollie Lurry, Elma Rogers, Carl Rogers, Carrie Lurry Rogers, and Carrie's husband Claud Rogers. (Courtesy of Jane Moore Burrows.)

Claud Buster and Carrie Lurry Rogers, the parents of Mary Rogers Bazemore, lived in this home on Blake Road. They had previously lived on the farmland where the present-day Walnut Grove Lake subdivision is located. (Courtesy of Carolyn Bazemore.)

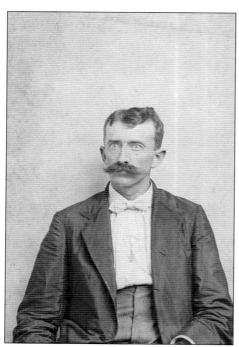

Charles Monroe Reinbold purchased 129 acres on Rocky Point Road prior to 1900. He married Essie Harpole, and they had two children. Son James Monroe Reinbold was born in Cordova in 1906 and married Susie Mae Bazemore, a teacher at Cordova School. Daughter Mildred Reinbold married Hardy Campbell. (Courtesy of Jo Hall.)

The Charles Monroe Reinbold family stands in front of their home on Rocky Point Road. The Reinbolds had two children, a boy and a girl. In the photograph are, from left to right, Monroe Reinbold, Mildred Reinbold Campbell, Essie Harpole Reinbold, and Charles Monroe Reinbold. (Courtesy of Jo Hall.)

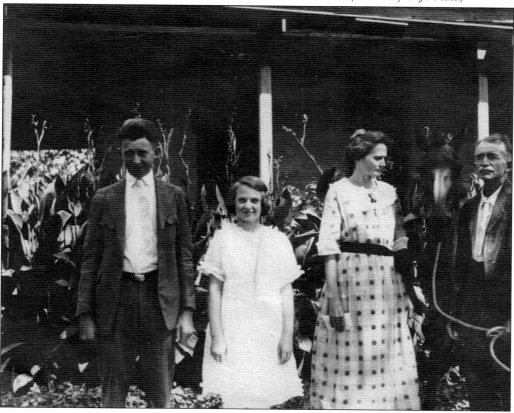

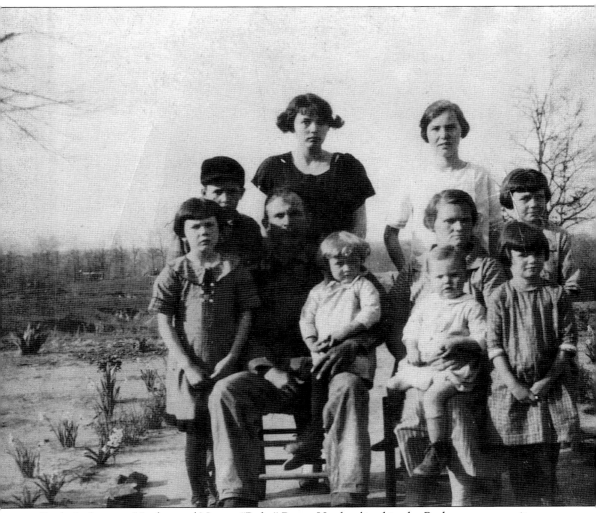

Frederic Augusta Hooker and Norma "Ruby" Bryan Hooker lived in the Bethany community on Raleigh-LaGrange Road at Pisgah. Their home was on land once owned by Ruby's grandfather John Alexander Bryan. Fred and Ruby were married on December 10, 1910, at a picnic in Cordova by Walter Granville Allen. Fred's grandparents Frederick Augustus Hooker and Sarah Ann Payne Hooker were considered founders of the Fisherville Community, having arrived in Shelby County in 1836. This photograph was taken before the birth of the Hookers' two youngest children, Joseph Clark ("J.C.") and John Robert ("Bobby"). Included here are, from left to right, (first row) Agnes Lucille, Fred (holding Alta Evangeline), Ruby (holding Norman Bryan, or "Buddy"), and Burnice Louise; (second row) James "Jimmie" Fredric, Lula May Magdaline, Thelma Lena, and Malissa Ann. All of the Hooker children attended Cordova School. Three of the Hookers' sons—Jimmie, Buddy, and J.C.—served in the Army in World War II during the same time period; Buddy was killed while serving with the 104th in Halle, Germany, on April 18, 1945. Bobby served during the Korean conflict. Seven generations of the Hooker family have resided in the Cordova area. (Courtesy of Darlene Hooker Sawyer.)

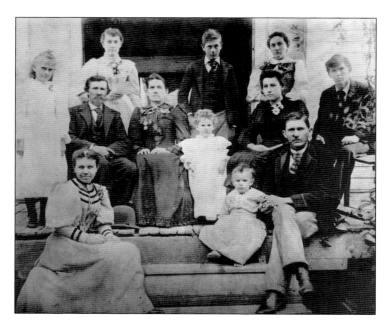

In this image are, from left to right, (first row) Jeannie Lee Schwam Schneider, baby Charles Henry Schwam, and John Henry Schwam; (second row) Sarah Elizabeth "Betty" Schwamm, Ferdinand Schwam, Nancy Jane Shakleford Schwam, Florence Ann Schwam Yates, Lula Ophelia Tucker Schwam, and Phillip Edward Schwam; (third row) Mary Annie Schwam, Ferdinand "Fred" Schwam Jr., and Florence Tucker. (Courtesy of Norma Schwam Miles.)

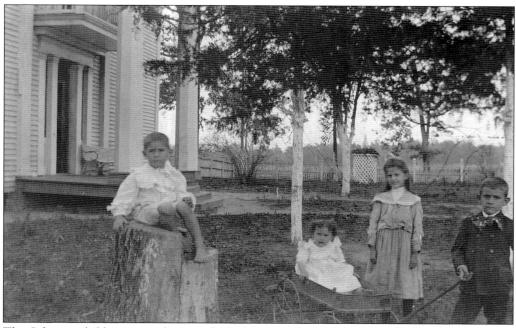

The Schwam children were photographed playing in front of the James E. Goodlett house on Macon Road in 1903. Their father, John Henry Schwam, was overseer of the Goodlett farm. This location is now the site of the Evangelical Christian School. The children are, from left to right, Charles Henry, Ethel May, Florence Ann, and Edward Otto. The Goodlett Farm, which had previously been owned by the James Abernathy Creath family, spanned approximately 1,500 acres. (Courtesy of Norma Schwam Miles.)

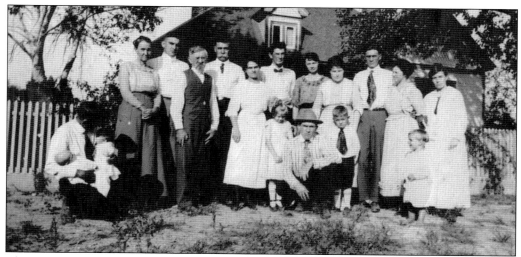

The Schwams came to Cordova in 1899 from Centerhill, Mississippi. Some of the Schwam family changed the spelling of their name from Schwamm. Pictured above are, from left to right, (first row) John Henry Schwam (holding Richard Lee Schwam and Lois Claire Schwamm), Geneva Schneider Green, Charles Henry Schwam Sr. (with hat), Charles Henry Schwam Jr., and James Howard Schwam; (second row) Nancy Jane Shackleford Schwamm, Edward Otto Schwamm, Ferdinand Schwamm, William Schneider, Mary Schwam Shackleford, two unidentified Shacklefords, Carrie Ellis Schwam, Ferdinand "Fred" Schwam Jr., Maggie Schwam, and Jennie Lucinda Poston Schwam. Pictured below are, from left to right, Robert Earl Schwam Sr., Charles Henry Schwam Sr., Richard Lee Schwam, John Terrell Schwam, Mary Virginia Schwam Woollard, John Henry Schwam, Margaret Elizabeth Schwam, Jennie Lucinda Poston Schwam, Joseph Maxwell Schwam, and James Howard Schwam. (Both courtesy of Norma Schwam Miles.)

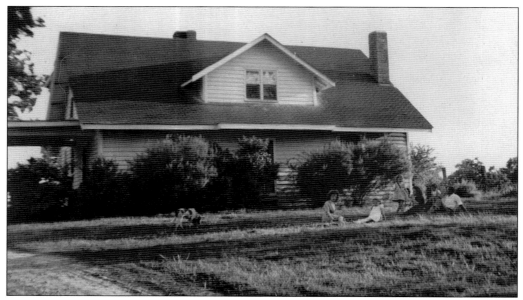

The Schwam home on Macon Road was once the homesite of early settler Thomas Allen. Allen called his property Pleasant Hill and had a small family cemetery on the grounds. (Courtesy of Norma Schwam Miles.)

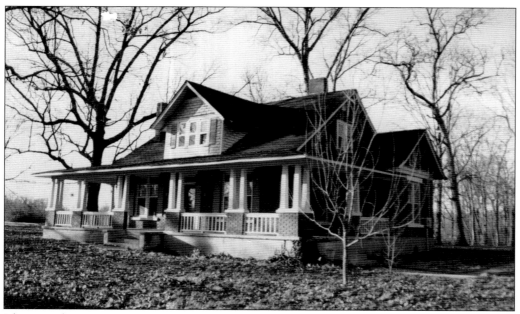

The Snowden House at 8652 Macon was built in 1913. Parts of this home were auctioned off, with proceeds going toward the Cordova Community Center debt for purchase of the old Cordova School building. This was the first home Norma Rogers lived in when her family, the Prichards, moved to the area in 1938. (Courtesy of Cordova Museum.)

Eddie Sanderlin was born in 1902 to William Thomas and Eula Pauline Webber Sanderlin. She married James "Rogers" Humphreys, son of James Baxter and Linnie Rogers Humphreys. She was a Cordova School teacher for many years and was fondly remembered by her students. (Courtesy of Cordova Museum.)

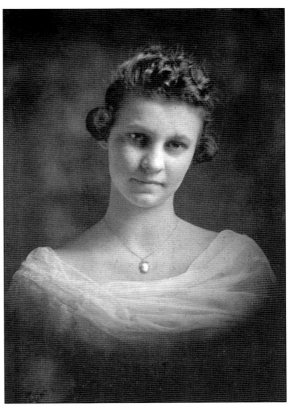

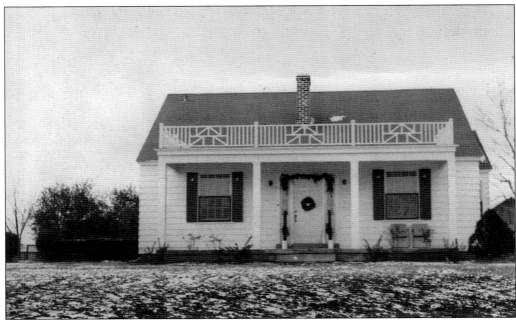

Eddie and Rogers Humphrey's new home was located west of the Germantown and Macon Road intersection. (Courtesy of Sarah Hall Bowlan.)

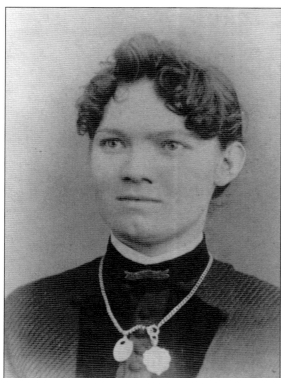

Ruth Anna Sullivan married Emmett Cornelius Humphreys. She and her sisters made lots of beautiful quilts for their children and grandchildren. She was the mother-in-law of Helen Neely Humphreys, Cordova School principal. (Courtesy of Harold Burrows.)

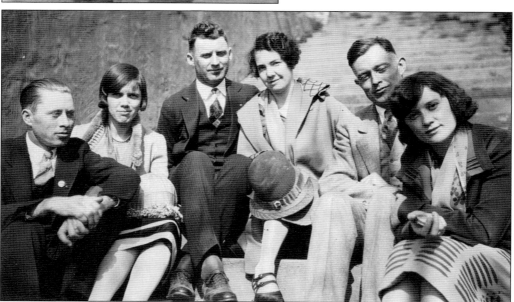

Pictured here are, from left to right, John Talmage Burrows; John's wife, Mary Humphreys Burrows; two unidentified friends; Sidney Elder Burrows; and Sidney's wife, Nell Harris Burrows. The Burrows brothers grew up on a farm in Cordova and both worked in Memphis for the US Postal Service after serving in World War I. John and Mary moved from Memphis to Germantown in 1938. Sidney and Nell lived at the homesite on Rocky Point. (Courtesy of John Burrows.)

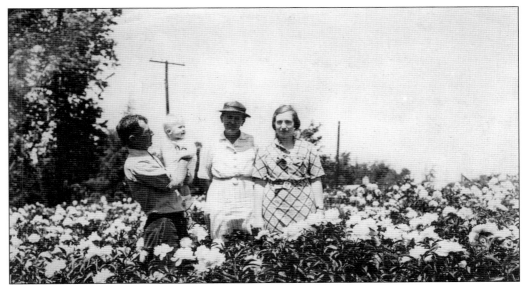

Alburn Lycomedes "A.L." Moore was a successful flower farmer in Cordova, as shown by this lovely field of peonies. A.L. is holding his granddaughter Jane Moore Burrows and standing next to his wife, Gertrude Rogers Moore, and daughter-in-law Eva Byrd Moore. (Courtesy of Jane Moore Burrows.)

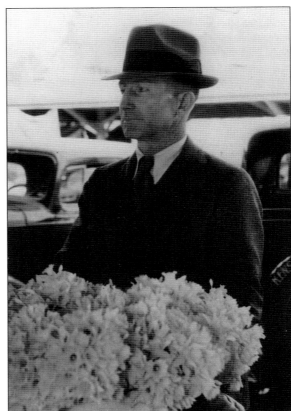

A.L. Moore is holding some of the beautiful daffodils grown on his Bonniebrow Farm. This farm was located on Macon Road to the west of the present day Cordova Post Office. His father-in-law, Jasper Rogers, said he would never amount to anything as a farmer. Many years later, after Jasper's death, A.L. received the honor of being a Tennessee Master Farmer. (Courtesy of Jane Moore Burrows.)

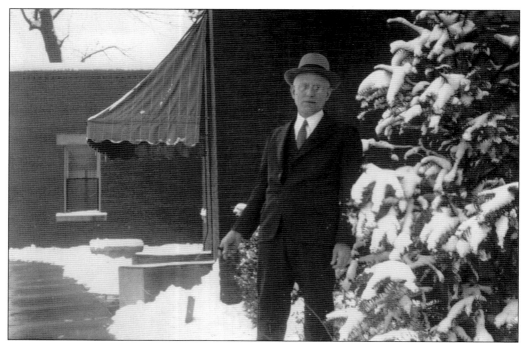

Dr. Clarence Alvy Chaffee, pictured above, came to Cordova in 1919. He was widely known throughout the Mid-South as a leading doctor. He is standing beside his clinic that was located on Macon Road. Because there was no electricity, telephone, or rural mail delivery, his patients could not call in for an appointment. His home, pictured below, was next door to his clinic. (Above, courtesy of Cordova Museum; below, John L. Garrison Jr.)

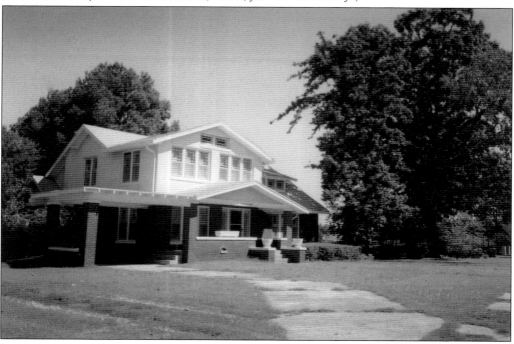

Dr. John Thomas Carter Jr. was a very personable and caring doctor who often made house calls to attend sick patients. He practiced in Cordova for 13 years before moving to Germantown, where he practiced another 25 years before retiring. He was married to Leanora Chafee Carter, niece of Dr. Clarence Chaffee. (Courtesy of John T. Carter Jr.)

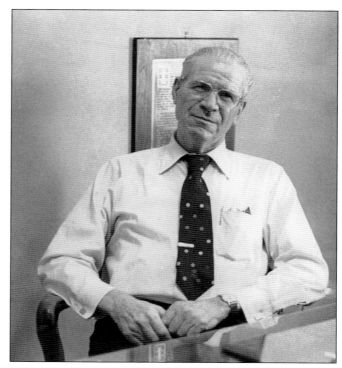

This home on Sanga Road at Thor Road with an unusual style of architecture was built for the Rast family in 1920 and has been exceptionally well maintained. It later became the home of Dr. John Carter, a widely known doctor who served the medical needs of the Cordova community for approximately three decades. (Courtesy of Darlene Sawyer.)

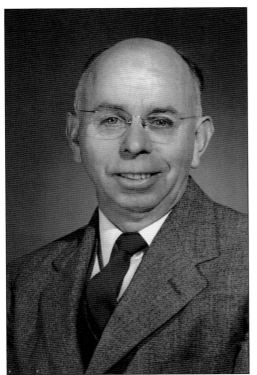

Dr. Lemuel Whitley Diggs (1900–1995) joined the faculty of the University of Tennessee, in Memphis, as assistant professor of pathology in 1929. He married Beatrice Moshier in 1930. Doctor Diggs did extensive research in the field of sickle cell anemia, writing a book from his research called *Morphology of Human Blood Cells*. He recommended the establishment of a blood bank at John Gaston Hospital in 1938 and encouraged hospitals throughout the nation to collect, store, and dispense blood and plasma during World War II. The Diggs family moved to Cordova in 1947, purchasing land on Raleigh-LaGrange Road that had previously been owned by the Galloways. Below is the Diggs family at the airport. Daughter Peggy stands in front, and behind her are, from left to right, Beatrice, Doctor Diggs, daughter Alice, and sons John and Walter. (Left, courtesy of Cordova Museum; below, courtesy of Norma Schwam Miles.)

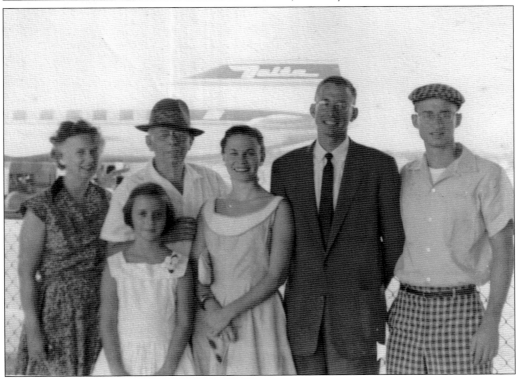

Edith Moore, daughter of George Edwin and Rachel Bartlett Moore, tended to mothers and babies after childbirth. She helped people who were sick with pneumonia and other illnesses, and offered advice on how to treat wounds. She would take books to read to the children while parents went out. Edith never married. She was the sister of Alburn Lycomedes "A.L." Moore. (Courtesy of Jane Moore Burrows.)

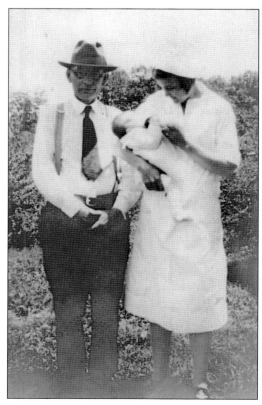

James Nolen Johnson Sr. is standing with Edith Moore, who was helping to care for his baby daughter Nancy Ellen Johnson. Johnson married Mamie Gertrude Burrows, daughter of John Hamilton Burrows and Izzer Dora Moreland Burrows. (Courtesy of Jane Moore Burrows.)

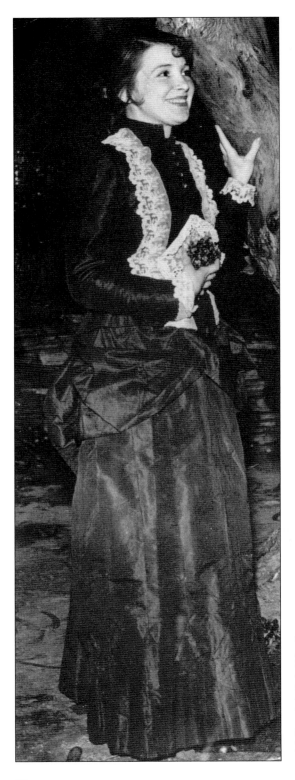

This dress was handmade from red
material and white lace purchased at B.
Lowenstein & Bros. Department Store
about 1877. Starke Redditt purchased
the material for his daughter Cynthia.
Phinie Greene Poston Wheelwright,
great-granddaughter of Starke, is
pictured in the dress at a 1933 party.
(Courtesy of Annette Baker Carroll.)

This 1925 photograph shows, from left to right, William Rush Redditt, Eunice Jewel Redditt, Albert Pleasants Redditt, and Callie Lee Redditt. William was first cousin of the other children but was more like a brother. After his mother died, he was raised by her sister Eddie Pleasants Redditt, who was the mother of the other children. (Courtesy of Charles Baker.)

Sister and brother Lela Belle Humphreys and Emmett Cornelius Humphreys were children of James Fletcher and Sarah Elizabeth Baxter Humphreys. Emmett married Ruth Anna Sullivan, and their son Charles Emmett Humphreys married Helen Neely, the longtime principal of Cordova School. Lela married Samuel Elbert Bazemore, and their son Gordon was a Cordova postmaster for many years. (Courtesy of Jane Moore Burrows.)

Francis Joseph Schwaiger married Edith McCalla Schwaiger, and they lived next door to the Cordova School where she was custodian. Francis worked for Remington, a typewriter company. Both of their sons, John and Francis, played on the Cordova School basketball team and later played at Memphis State, also known as the University of Memphis. (Courtesy of Cordova Museum.)

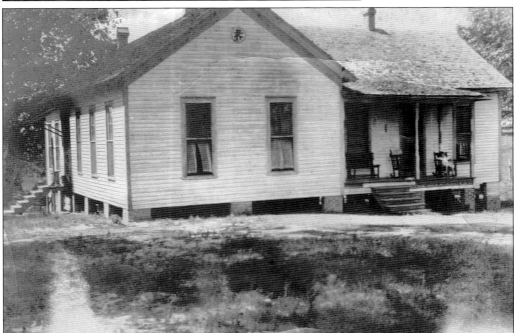

This house was used as the schoolhouse just prior to erection of the first permanent brick school building next to it. It became the home of Francis and Edith Schwaiger, and Edith became the custodian of the new school building. (Courtesy of Cordova Museum.)

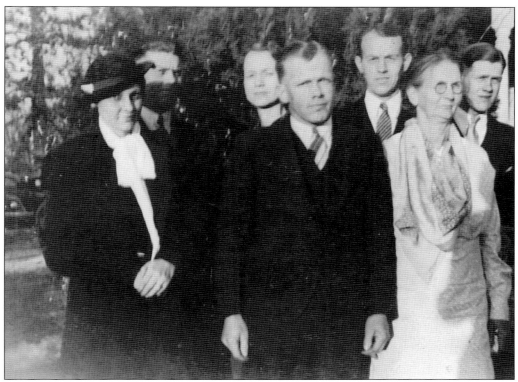

The James Baxter Humphreys family grew vegetables and flowers. Seen here are, from left to right, (first row) Eddie Sanderlin Humphreys, James Rogers Humphreys, Lillian Wellborn Humphreys, Charles Augustus "Little Charlie" Humphreys, Jasper Clinton "Buster" Humphreys, Linnie Rogers Humphreys, and Edward Gordon Humphreys. (Courtesy of Jane Moore Burrows.)

The home of James Baxter Humphreys and Linnie Mae Rogers Humphreys stood on Macon Road and Germantown Parkway, where the Walgreens and Malco movie theater are today. Ed and Bernice Humphreys lived here also before building their house. (Courtesy of Carolyn Bazemore.)

The Ciarlonis were the first Italians to live in Cordova. Here, grandmother Alcilia Ciarloni and parents Della and Robert Ciarloni Sr. are dressed for the wedding of son Leonard Ciarloni to Dorothy Barbaro. (Courtesy of Leonard and Dorothy Ciarloni.)

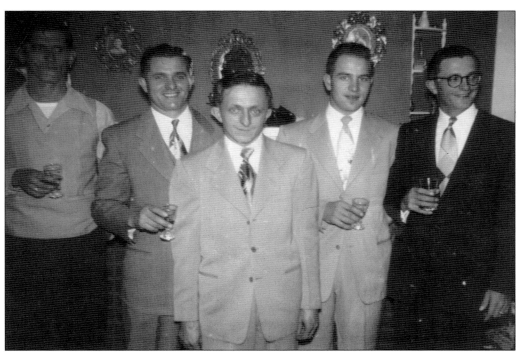

Chick Barbaro, William Ciarloni, Robert Ciarloni, Alfred Morton, and Leonard Ciarloni are dressed up in 1951 for Mary Ciarloni Bistolfi's wedding. (Courtesy of Leonard and Dorothy Ciarloni.)

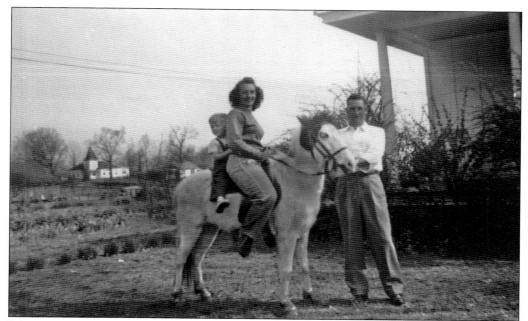

John Dewitt Ellis Jr. holds the pony for his wife, Eunice McNeely Ellis, and son Jerry McNeely Ellis in front of their home. The Cordova Presbyterian Church on Fay Road is in the background. (Courtesy of Barry and Mary Rogers.)

Mozelle Reid Farley built this home in 1941 after her husband, Forest, died. Forest was a clerk in the Fred Houston Store in Fisherville until he and Houston partnered in purchasing a store in Cordova, the Houston & Farley Store. Farley and Mozelle later bought the business, and it became the Farley Store. Today, the Farley home has been renovated into a nice Italian restaurant called Café Fontana, owned by Tom and Valerie Schranz. (Courtesy of Cordova Museum.)

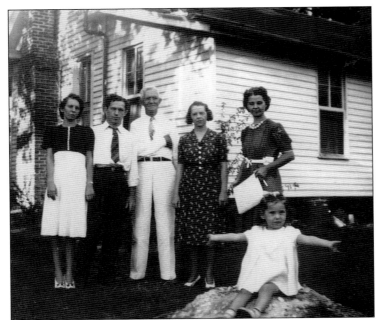

Joseph Wallace Leigh and wife Luella were longtime residents of Cordova. They had five children: Joe, Louise, Homer, George, and Yarbrough. The Leigh family made their home in Cordova on Rocky Point Road. Pictured here are, from left to right, Christine Leigh, Yarbrough Leigh, Joseph Wallace Leigh, Louise Leigh, Anne Leigh, and Ruth Leigh (child). The home at one time belonged to William David Yarbrough, father of Luella Yarbrough Leigh. (Courtesy of Judy Tingle.)

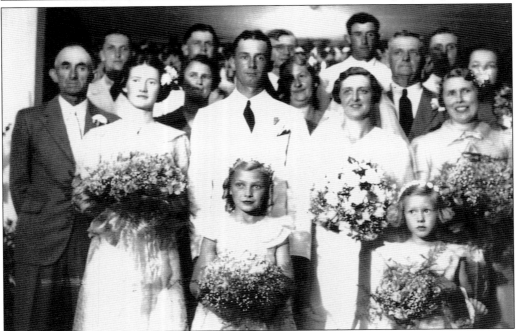

This wedding photograph of Malcolm Rogers and Sarah Ellis was taken on June 16, 1938. It includes, from left to right, (first row) flower girls Doris Anne Latting and Anne Burrows; (second row) bridesmaid Virginia Rogers, Malcolm Rogers, Sarah Ellis Rogers, and bridesmaid Sue Reinbold; (third row) father of the groom Charles Rogers, mother of the groom Cassie Rogers, mother of the bride Annie Yates Ellis, and father of the bride John Dewitt Ellis; (fourth row) John Dewitt Ellis Jr., Ed Humphreys, Pastor J.T. Carter, Wesley Rogers, Leonard Rogers, and Mary Will Rogers. (Courtesy of Norma Prichard Rogers.)

James Monroe Reinbold and Susie Mae Bazemore were married in the Cordova Presbyterian Church on July 10, 1942. Officiating at the wedding ceremony was David Alvin Ellis. Monroe worked at the penal farm, and "Miss Sue" was a Cordova School teacher. (Courtesy of Carolyn Bazemore.)

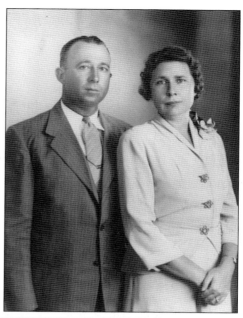

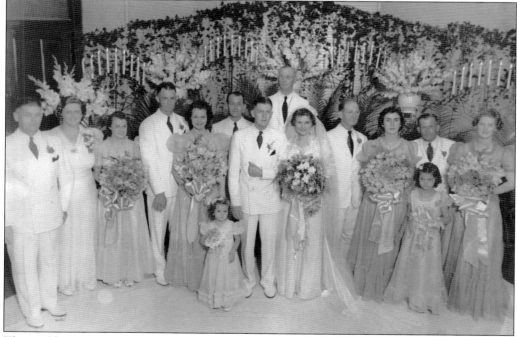

The wedding of Edward "Ed" Humphreys and Bernice Anderson occurred on July 26, 1939, at the Cordova Presbyterian Church. The adult members of the wedding party are, from left to right, Rogers Humphreys, Sarah Ellis, Rebecca Bazemore, Malcolm Rogers, Dorothy Anderson Holland, Clinton Humphreys, Edward Humphreys (groom), Brother Wheeler (minister), Bernice Anderson Humphreys (bride), William Robert Anderson, Minnie McRae, Powell Cutliff, and Virginia Rogers Doocy. In front stand flower girls Patricia Humphreys (center) and Barbara Hamner (right). (Courtesy of Carolyn Bazemore.)

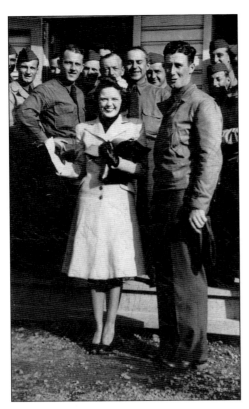

Norma Prichard and Wesley Rogers were married March 31, 1942, at Fort Eustis, Virginia, while Wesley was serving in the Army. Military buddies attended the chapel wedding and presented them with a cap full of money as a wedding gift. (Courtesy of Norma Prichard Rogers.)

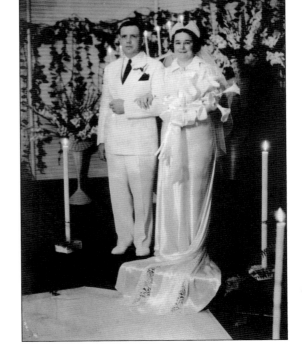

Helen Neely and Charles Emmett Humphreys married in 1938 in Shelby County, Tennessee. Charles was a successful farmer, and Helen was a longtime principal of Cordova. (Courtesy of Carolyn Bazemore.)

Two

FARMS, FLOWERS, FELLOWSHIP

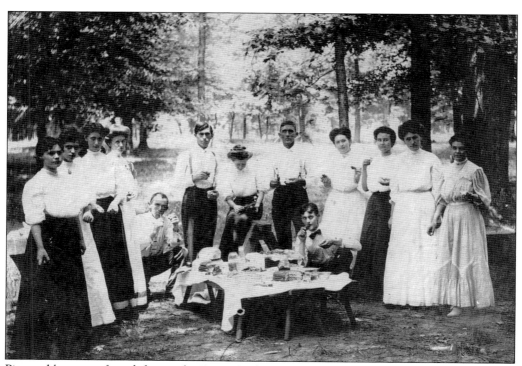

Pictured here are, from left to right, Lottie Kirk, Gertrude Strong, Irene Moore, Callie Woods, Clyde Yates, Joe Strong, Jennie Lucinda Poston, John Henry Schwam, Joe Arrington, Annie Yates, Chloe Rutledge, Blanche Strong, and Effie Mai Mullins. (Courtesy of Nancy McDaniel.)

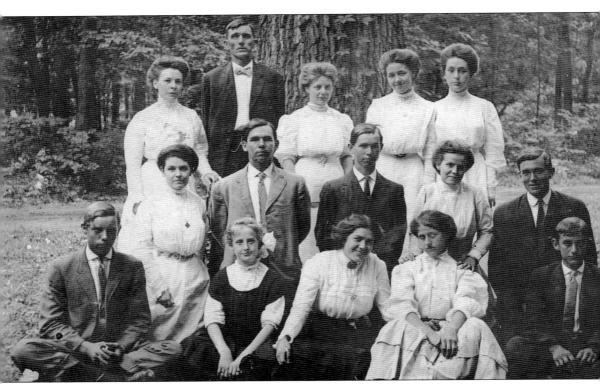

Among those pictured in this c. 1908–1910 photograph are three couples dating prior to their marriages. In the second row, starting on the far left, the first four young people are Effie Mai Yarbrough, William Guy Mullins, Thomas Phillip Mullins, and Bettie Leolla Yarbrough. The Yarbrough girls were sisters, and the Mullins boys were brothers. They later had a double wedding in 1912. Behind them, to the far left in the third row, stand Jennie Lucinda Poston and her future husband, John Henry Schwam. The woman to Schwam's right is possibly Alice Augusta "Gussie" Allen. At a Cordova picnic similar to this, Fred Hooker and Ruby Bryan were married by Squire Walter Granville Allen on August 10, 1910. Picnics enabled young people to meet one another, to catch up on the local news, and share farming and canning tips. It also gave the women a chance to show off their cooking and new dresses. The other people in the photograph have not been identified. (Courtesy of Nancy McDaniel.)

This is the wedding invitation of sisters Effie Mai and Bettie Leolla Yarbrough, who married brothers William Guy and Thomas Phillip Mullins in a double wedding at Cordova Baptist Church on June 25, 1912. (Courtesy of Nancy McDaniel.)

Mr. and Mrs. W. D. Yarbrough
request the honor of your presence
at the marriage of their daughters
Effie Mai
and
Bettie Leolla
to
Mr. William Guy Mullins
and
Mr. Thomas Phillip Mullins
on Tuesday the twenty fifth of June
one thousand nine hundred and twelve
at two o'clock
Baptist Church
Cordova, Tennessee

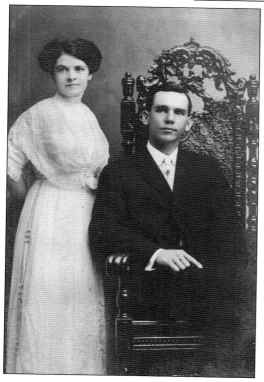

Here are Effie Yarbrough and William Mullins on their wedding day. She was the daughter of William David Yarbrough and Sarah Frances Locke, and he was the grandson of Rev. Lorenzo Dow Mullins Sr., the first regular pastor of the Methodist Episcopal Church founded in 1845. The church, which acquired the name Mullins United Methodist Church, is at the Walnut Grove and Mendenhall Roads intersection. (Courtesy of Nancy McDaniel.)

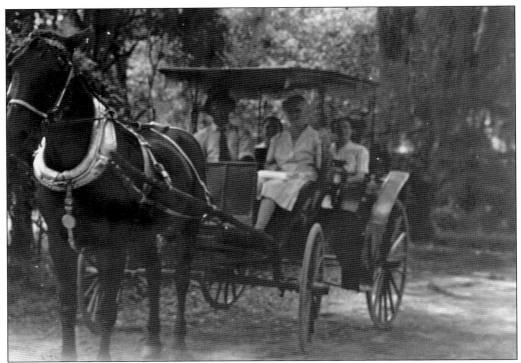

Early forms of transportation were by foot, horse, buggy, or wagon. Some buggies were meant for joyriding (above) or simply a means of transportation, and other buggies were used for farm work and hauling heavy items. Monroe Reinbold and Susie Mae Bazemore Reinbold (below) are on their way to buy groceries. Sue was a teacher at Cordova School. (Both courtesy of Jo Hall.)

Elmo Edward Bryan is seen crossing the Wolf River Bridge on Collierville-Arlington Road. Elmo was the son of Aaron Malcolm Bryan and Lula Mae Keough Bryan. His great-grandfather Aaron Malcolm Bryan had come from South Carolina and settled in the Bethany community by 1848. The Bryans married into the Hooker, Strong, Lurry, Baxter, Ecklin, Berryhill, Sanderlin, Burrows, Nolley, Thomas, Jackson, Anthony, and Rutledge families, to name a few. (Courtesy of Bethany Christian Church.)

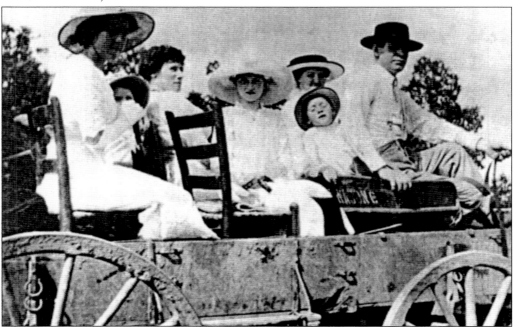

Jessie and Ella Dora Houston James are sitting in style in the front of this buggy on their way to Bethany Christian Church. Between them is son Lester "Buddy" James, and behind them are, from left to right, daughter Eva Dora James, unidentified, Myrtle Thompson Biggs (without hat), and daughter Bertha James. This photograph was taken around 1915. (Courtesy of Bethany Christian Church.)

This smokehouse was built out of cypress lumber in 1928 by Columbus Clark. Farmers had to raise their own food and meat because there was no electricity to power a refrigerator, and there were only a few stores. The smokehouse was left unpainted and was the building for curing meats. Hogs were butchered at the onset of cold weather, and the meat was cured with salt and hung inside the smokehouse. (Courtesy of John Lawrence Garrison Jr.)

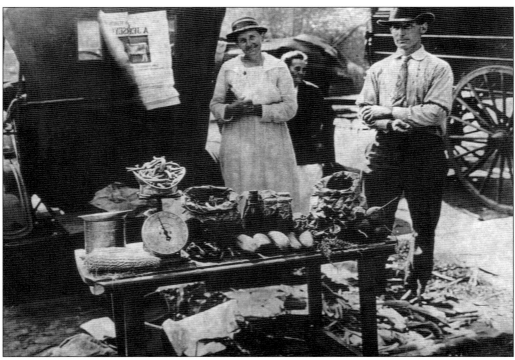

The Moore family grew flowers and vegetables and carried them to the Curb Market in Memphis by wagon and also by Model T. The Curb Market was located at the corner of Madison Avenue and Dunlap Street and also Poplar and Cleveland. Pictured are Gertrude Rogers Moore and husband A.L. Moore, who was the first Cordovan flower farmer. (Courtesy of Jane Moore Burrows.)

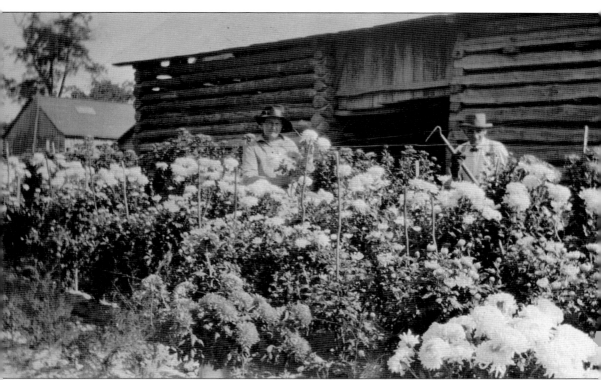

Gertrude Rogers Moore enjoyed raising flowers and vegetables her whole life. She is seen above getting help from her father-in-law, Rev. George Edwin Moore, with her beautiful chrysanthemum bed. The chrysanthemums were covered and heated in the fall so the cold weather would not hurt them. The old building in the background was one of the original structures built on Jasper Rogers's farm. It was built of logs cut from trees on the property. One end functioned as the corncrib, and the other end was used for storing cottonseed. Plows and tools were stored in the open section. George Edwin Moore was a Free Will Baptist minister. (Courtesy of Jane Moore Burrows.)

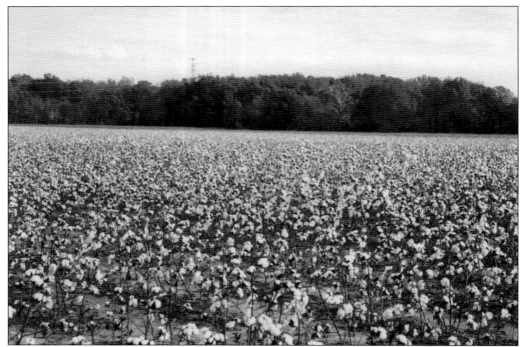

Cotton was the cash crop of the early Cordova settlers. Farmers also grew vegetables and flowers. Most residents continued as farmers until the 1970s. (Courtesy of Dorothy Ciarloni.)

During the 1940s, cotton sold for approximately $25 a bale, with each bale weighing about 500 pounds. It would take a good man a day or two to pick a bale of cotton. (Courtesy of Cordova Museum.)

The mule was a valuable farming commodity in the 1800s and early 1900s. Mules were bred as the offspring of male donkeys and female horses because they were stronger than a horse and more patient and intelligent than a donkey. They were used by farmers for plowing and pulling stumps before tractors were available. (Courtesy of Jane Moore Burrows.)

Keith Rogers is riding the family donkey while an unidentified cowboy is trying to shoot him. In the background are the Helen Neely Humphreys and Charles E. Humphreys General Merchandise store (H&N Grocery), Eddie B. Anderson's 10¢ store, W.R. Anderson's general merchandise store, and the train depot on the south side of Macon. (Courtesy of Barry and Mary Rogers.)

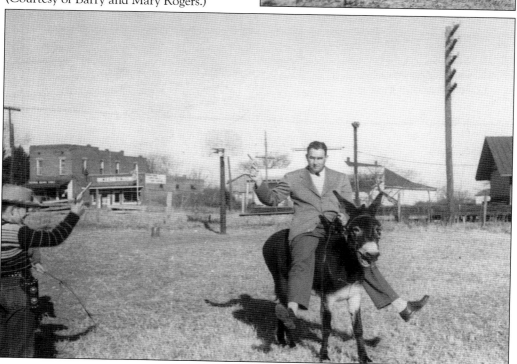

Lots of cats, dogs, chickens, ducks, horses, pigs, goats, sheep, and many other farm animals lived on the rural farms in Cordova. Pictured is Eunice Jewell Redditt, who was born in 1919 to Charles Albert and Eddie Maude Pleasants Redditt. (Courtesy of Annette Baker Caroll.)

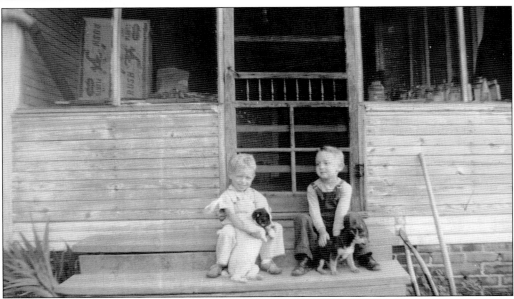

Cousins Jerry Ellis (left) and Barry Rogers play with puppies on the back steps of Jerry's home. Caring for pets instills important life lessons, such as responsibility, patience, love, loyalty, compassion, and respect for other living things. (Courtesy of Barry and Mary Rogers.)

George Clinton Moore is tending to a Jersey calf. The Moores were proud of their Jersey cows, but when milking got to be a chore, they changed to beef cattle. They also raised hogs and goats. (Courtesy of Jane Moore Burrows.)

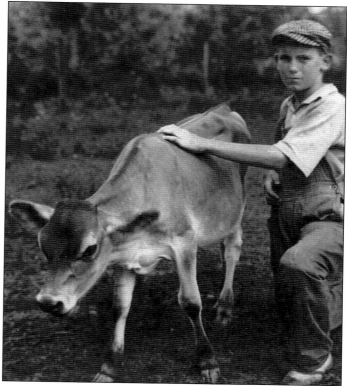

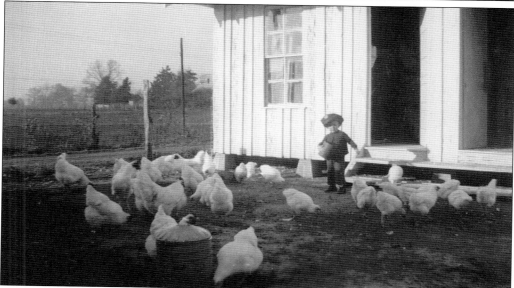

A young Barry Rogers is feeding the chickens and learning chores at an early age. Many of the rural families raised chickens in order to have fresh eggs and meat on hand at all times. The chickens ate bugs and worms they scratched up in the yard and were also given corn to supplement their diets. Little chicks grew quickly into big chickens and then became Sunday dinner. (Courtesy of Barry and Mary Rogers.)

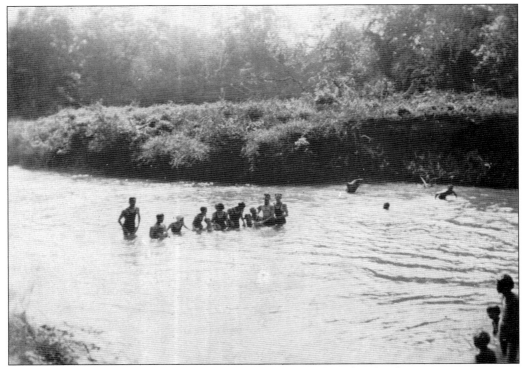

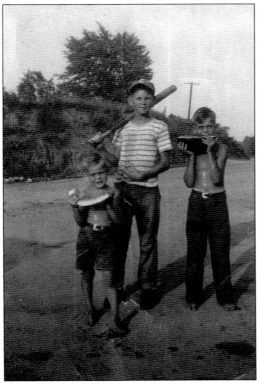

The Fred Hooker family went swimming in the Wolf River near the Houston Levee Bridge. They strung a 15-foot-high cable across the river from tree to tree. Adding a pulley and bar allowed the boys to drop off into the water, but they had to be agile enough to climb the tree. Families and friends camped out, caught and fried fish, and told a few ghost stories. (Courtesy of Jane Hooker.)

The boys enjoyed swimming but they also loved to play with slingshots, eat watermelon, and play baseball. Richard Hooker, Billy Bain, and John "Freddie" Hooker are seen standing in front of Fred Godwin's store at Pisgah and Macon Roads. Behind them to the left is the hill where the Mount Pisgah Church was built. (Courtesy of Billy Bain.)

The Grays Creek drainage ditch was constructed in 1920 or 1921 by the Shelby County government to drain the Cordova community area from a point on the Fayette County line in the Eads vicinity in a southwesterly direction to empty into the Wolf River. The purpose was twofold. First, it would drain an area that would allow many hundreds of acres to be used as productive farmland. Second, it would accommodate transportation needs so one could commute from point A to point B without relying on a canoe. The contractor used a steam shovel mounted on a barge, which was floated by the backwaters. In an area south of the former Raleigh-LaGrange Road at Mary's Creek, a Saturday-night dance was held on the barge, and it was destroyed by a fire caused by the boilers. Below, to pay for the construction of the drainage ditch, the Shelby County government levied a special drainage tax upon each farm it passed through. The ditch was fully paid for by 1930. (Both courtesy of John Lawrence Garrison Jr.)

No. 29

Grays Creek Drainage District

SHELBY COUNTY, TENN.
VS.

Harris, Gurney

To Assessment for the year 1933 on Tract No. 39 , 36 Acres
of Land in Grays Creek Drainage District,
Shelby County, Tennessee

1933

$ 72.36

Receipt Valid When Check Paid

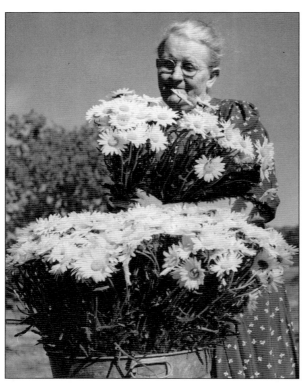

Gertrude Moore is preparing daisies for the Curb Market in Memphis. The Moores' Bonniebrow Farm was the first flower farm in the area. (Courtesy of Jane Moore Burrows.)

The largest landowner and flower farmer in Cordova was Edward Humphreys. (Courtesy of Dorothy Holland Anderson.)

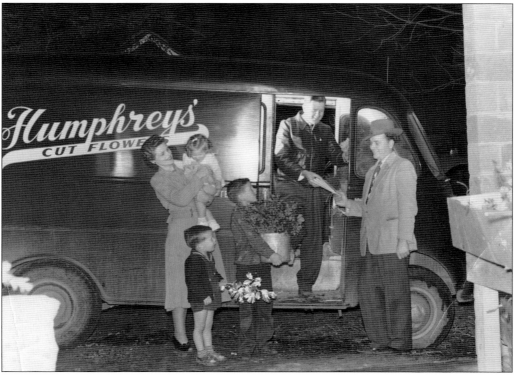

Eva Byrd Moore (at right), wife of George Clinton Moore, is seen gathering flowers for the Curb Market at Crosstown in Memphis. One summer in the late 1940s, Eva and Eunice Ellis (below), rode the train to Chicago and spent two weeks taking floral arrangement classes. Eva was the daughter of James Lester and Pruda Burcham Byrd. Eunice McNeely Ellis was the wife of John Dewitt Ellis and was as pretty as the flowers she grew. (Right, courtesy of Jane Moore Burrows; below, courtesy of Jerry McNeely Ellis.)

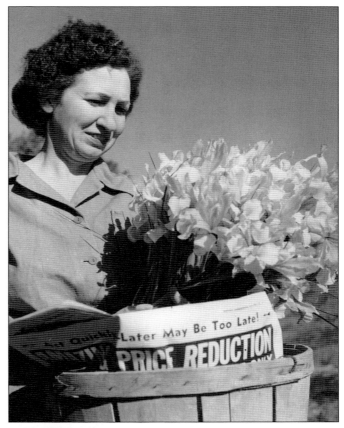

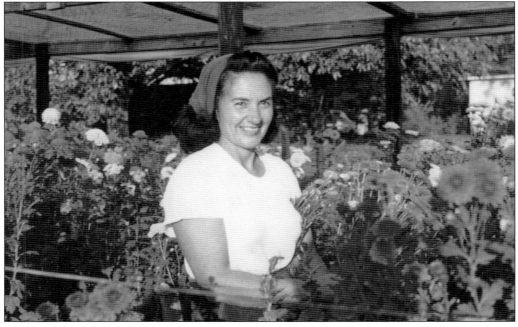

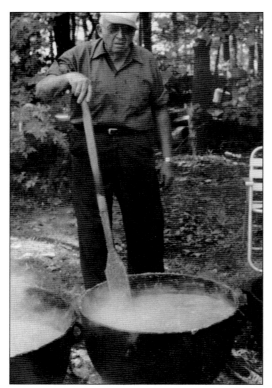

Making Brunswick stew was a necessary tradition for any social gathering. Each family would bring a vegetable (corn, butter beans, onions, peas, tomatoes, okra, potatoes, or peppers) or a type of meat (deer, beef, squirrel, dove, chicken, or goat) to add to the black pot. The stew cooked slowly all day and was stirred often, as demonstrated here by Monroe Reinbold. (Courtesy of Jo Hall.)

John Henry Schwam is pictured here sitting and relaxing at the family picnic on his property. He had 13 children, and all but one lived to adulthood. Most of his family enjoyed horseback riding into their adult years. His youngest son, Richard, is still riding at age 92. The Schwam family moved to the farm called Pleasant Hill in 1932. (Courtesy of Norma Schwam Miles.)

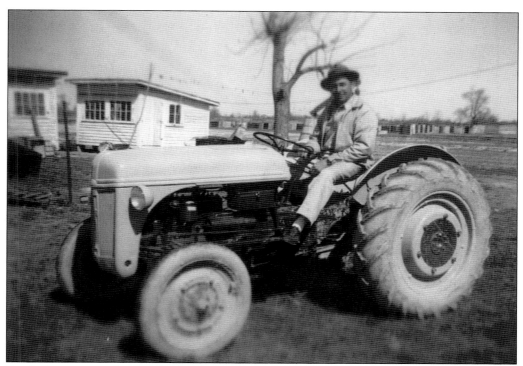

Frank Bursi is seen farming his land at 2301 Germantown Road, which he purchased in 1948. He was a baker by profession until wife Teresa decided to grow a garden that would turn into a truck farm, selling produce at the Curb Market at Cleveland and Poplar. Frank quit the bakery job to farm. This land sold in 1976 and later became part of the Wolfchase area, where Kohl's department store is located today. (Courtesy of Jo Hall.)

On Macon Road in Cordova, there is a bottle tree. As the home owners best explain, "Back in the day in the deep south folks would have a bottle tree in their yard to keep away the evil spirits." There is a beautiful glow of colors in the sunlight because of the many colored glass bottles. The bottle tree greatly enhances the historical streetscape of rural Cordova. (Courtesy of John Lawrence Garrison Jr.)

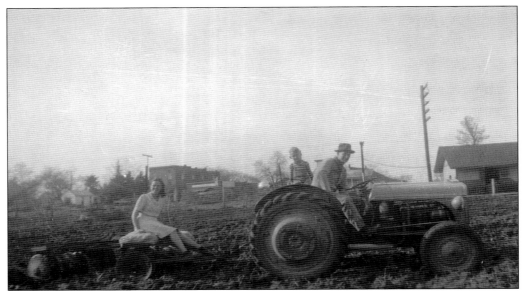

Oliver "Malcolm" Rogers is pictured on the tractor with his son Barry on the fender well. The young lady is Malcolm's sister-in-law Norma Rogers, the wife of Wesley Rogers. In the background are, from left to right, the post office, Cordova Grocery, Anderson's Store, and the train depot. (Courtesy of Barry and Mary Rogers.)

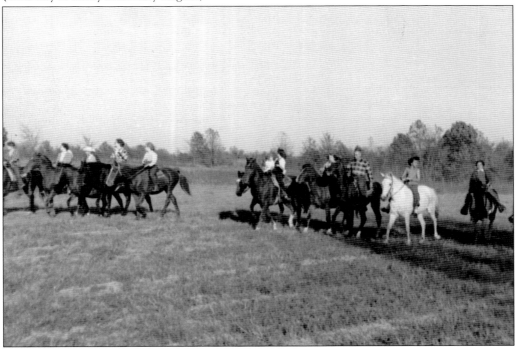

Riding horses and even mules was a pastime for the early rural families. Donkey ball games were popular fundraisers. Many of the families with enough land still enjoy owning and riding horses. The Cordova Bridle & Saddle Club evolved about 1959 from this favorite pastime and ended about 1971. (Courtesy of Yvonne Baker.)

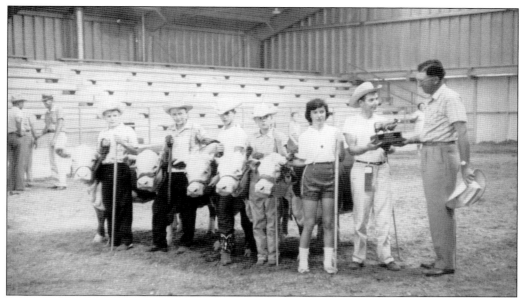

Saddle Clubs and 4-H Clubs afforded country boys and girls an opportunity to show off their farming and riding skills. Summer fairs with judged contests and rodeos provided competition for adults as well as the children. Here, Becky Baker, daughter of James and Ann Baker, won reserve champion at this competition shortly before her death. (Courtesy of Yvonne Baker.)

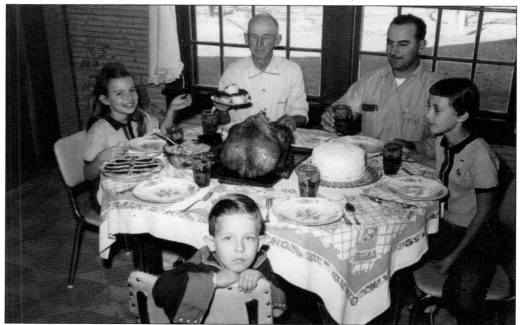

The James Baker family at one time had over 2,000 chickens as well as plenty of turkey and geese. James Baker is pictured at the table with his three children and his father as they enjoy Thanksgiving dinner. Wife Anna Leatherwood Baker is taking the picture. The little boy in the foreground is James "Jim" Baker Jr., and around the table are, from left to right, Rebecca ("Becky"), Austin (James's father), James ("Jimmy"), and Barbara Ann. (Courtesy of Jim Baker Jr.)

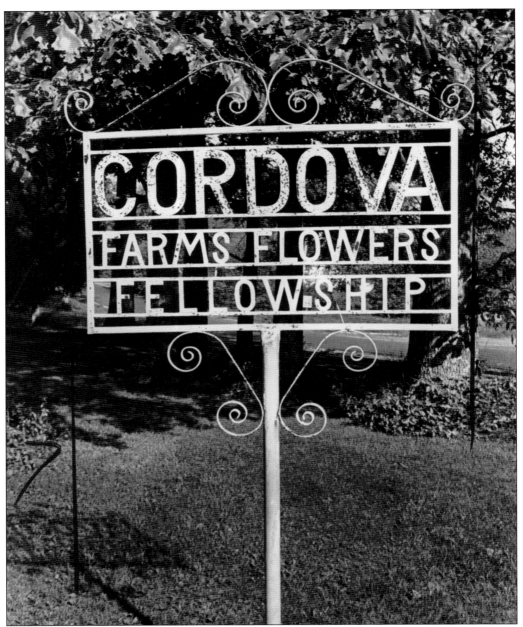

This Cordova sign, erected in the late 1930s, tells the community's history in three words: Farms, Flowers, Fellowship. The sign still stands at the same location on Rocky Point Road at Macon. At one time, 92 percent of the fresh flowers sold in Memphis came from farms in Cordova. The Moore family was the first to plant flower crops in Cordova, and others followed. Some farms specialized in one or two types of flowers best suited for their soil and workforce. A flower fair was held, and awards were given to the best in different categories. Meetinghouses, schools, and churches provided places to socialize. Picnic meetings were held, with several couples being married at these events. Visiting with neighbors who may have lived several miles away presented an opportunity to relax, share concerns, and renew friendships. (Courtesy of University of Memphis.)

Three

EARLY EDUCATION

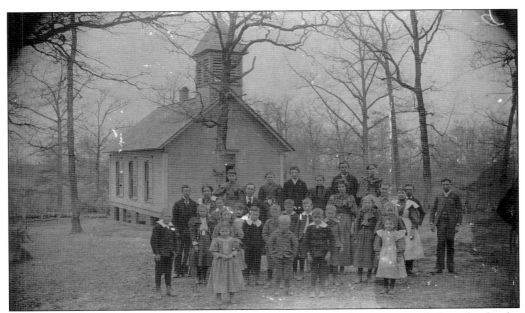

This school group picture dates to approximately 1895 or 1896. The structure is believed to be the first combined school and Sunday school building. The teacher would have been Alice Augusta "Gussie" Allen, believed to be standing in the last row, second from the left. Thomas Walter Yates taught after Gussie, and is thought to be the man standing to her right. The small girl in the front row wearing the white pinafore is Effie Mai Yarbrough, who later married William Guy Mullins. She was born in 1889. The taller girl behind her, also in a white pinafore, is her sister Lu Ella Yarbrough. Lu Ella was born in 1882 and married Joseph Wallace Leigh. (Courtesy of Nancy McDaniel.)

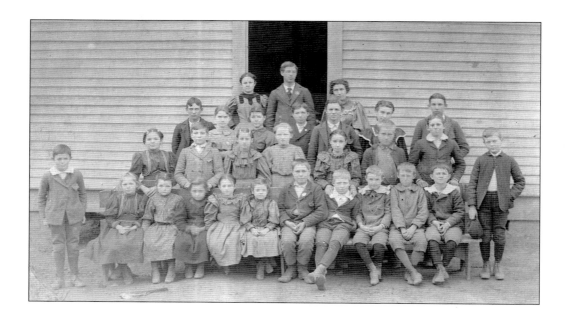

Above are children who attended classes in the first Cordova School building when Alice Augusta "Gussie" Allen was teaching. This image is from around 1895. The first school burned, and a second, pictured below, was erected. The new building was made larger to accommodate the growing number of students. Notice the four windows and two chimneys in this photograph compared to the earlier building. This school was built on the property donated by James Watson Allen. It burned in the spring of 1904. (Above, courtesy of Nancy McDaniel; below, Carolyn Bazemore.)

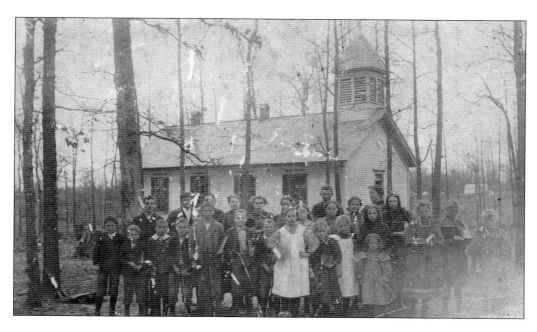

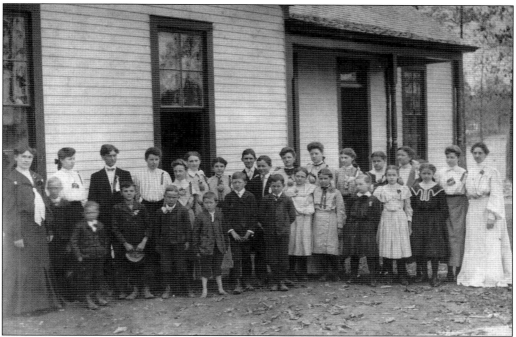

The building above was used as the third schoolhouse. It sat to the northwest side of the burned structure. Some of the people in this 1905 photograph include, in no particular order, Sadie Yates Strong, Bea Owen Houpe, Joe Arrington, Lottie Owen Pierce, Annie Lily Yates Ellis, Effie Yarbrough Mullins, Jennie Poston Schwam, Gertrude Strong, Eddie B. Hamner Anderson, Betty Yarbrough Mullins, and Ollie Lurry. This building later became the home of Francis Schwaiger and his wife, Edith, the school custodian. Below, the first permanent brick school was built in 1913 in the same spot where the second building had burned, on the land donated by Jim Watson Allen. (Both courtesy of Cordova Museum.)

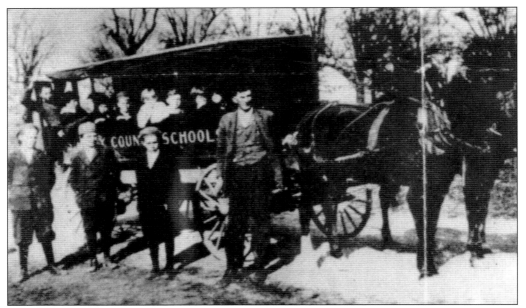

Above is the first public school transportation, a wagonette. The wagonette driver shown here was Phillip Edward Schwam, brother of John Henry Schwam. Curtains made of canvas were used to protect the children from the rain and cold weather. Sometimes, parents would heat a brick and wrap it in a cloth to send along with their child to keep feet and hands warm. Below is a photograph of all the children enrolled at Cordova School in 1913. Classes were comprised of two grades—first and second, third and fourth, fifth and sixth, and so forth. The school offered grades one through ten. The following year, an 11th grade was added. Not until 1924 was a 12th grade offered. Starting in 1933, Cordova became an elementary school for grades one through eight and remained so until closing in 1973. (Both courtesy of Cordova Museum.)

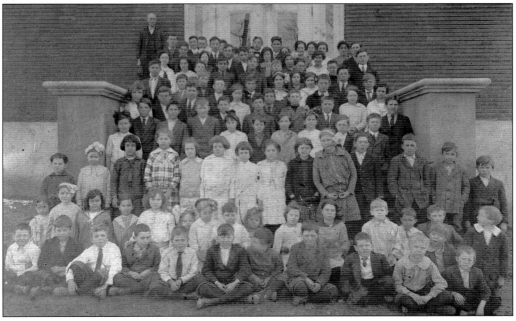

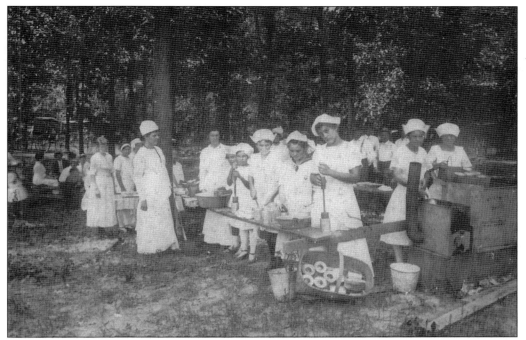

Canning Club was before the days of 4-H Club, around the early 1900s. Members met across the road from Cordova School. In the background, note the buggies that brought some of the girls to the event. Others walked, rode horses, or came in a wagon, since those were the only methods of transportation. Founded in 1915, Cordova's was the first 4-H Club in Shelby County. (Courtesy of Jane Moore Burrows.)

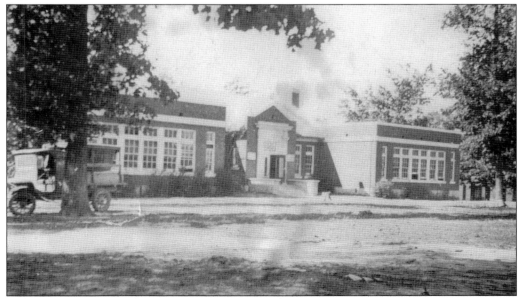

The second school bus, about 1918, was a motorized version of the earlier wagonette. The canvas curtains were still used to keep the students warm and dry during cold or rainy weather. (Courtesy of Cordova Museum.)

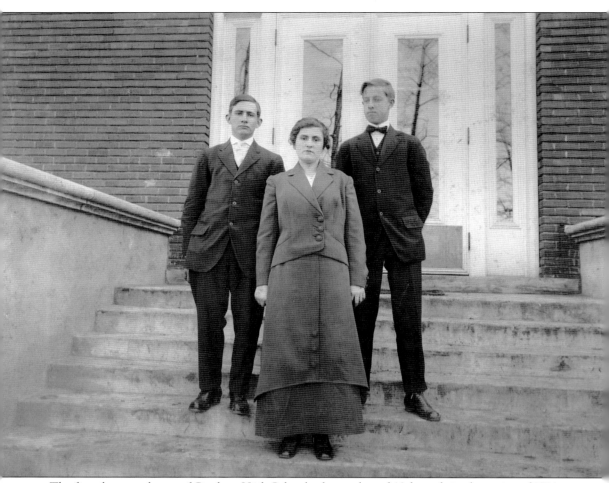

The first three graduates of Cordova High School, who graduated 10th grade in the spring of 1914, were, from left to right, Earl Humphreys, Lucy Claude Riggins, and Walter Carter. The school opened in 1913 offering grades one through ten. The next year, an 11th grade was added, and these three students returned and graduated a second time. The students did not have electricity, and the restrooms and cafeteria were in two separate buildings behind the main school building. Repeat graduates occurred again when a 12th grade was added in 1924. The first graduating senior class at Cordova High School was not until 1925. In 1930, Cordova dropped grades 10 through 12, and students were sent to Germantown High School. Cordova taught grades one through nine until 1933, when the ninth grade was dropped. Cordova remained an elementary school for first through eighth grades until it closed in 1973. It became a tradition for students to pose for all class pictures on the school's front steps. (Courtesy of Cordova Museum.)

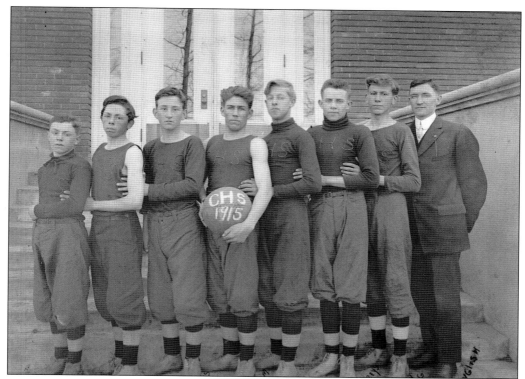

The 1915 boys' basketball team consisted of, from left to right, Murrell Parrott, Cedric Pound, John Riggins, Otto Schwam, Walter Carter, Baxter Humphreys, and Turley Strong. They are standing on the front steps of Cordova School with Prof. Dan English. (Courtesy of Cordova Museum.)

The members of the Cordova girls' basketball team are seen sporting their middies in 1917, when legs were not to be shown. Most teams had six players and played three divisions of the court style of play, with only two dribbles. (Courtesy of Cordova Museum.)

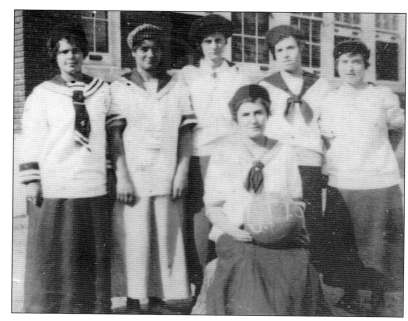

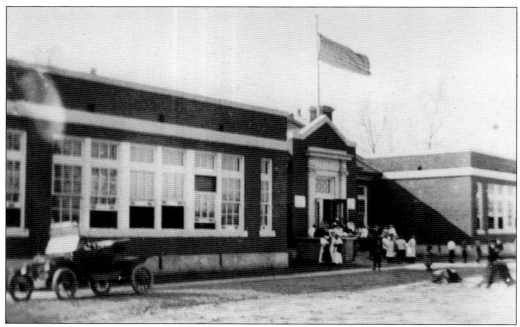

Note the raised windows in the Cordova School building, which lacked air conditioning in 1920. Today, some men recall jumping out the windows for recess instead of taking time to go outside through the doorway. (Courtesy of Carolyn Bazemore.)

The third school bus provided a lot more protection for the students. It was painted in patriotic red, white, and blue. The two bench seats of the past were replaced by rows of individual metal seats. Later, state law would require the buses to be painted yellow. (Courtesy of Cordova Museum.)

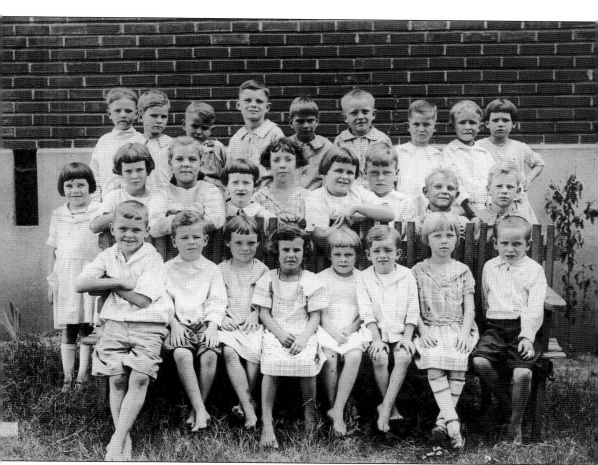

Cordova School's first and second grades are pictured here in 1922. The students are, from left to right, (first row) Francis Schwaiger, Philip Mullins, two unidentified, Rebecca Bazemore, James F. Hooker, Stella Coulter, and Eugene Rast; (second row) Annie Jones, Mabel Yates, unidentified, Virginia Rogers, unidentified, Evelyn Carter, Carl Rogers, and two unidentified; (third row) four unidentified, Robert Schwam, three unidentified, and Mary Hoper Summers. (Courtesy of Carolyn Bazemore.)

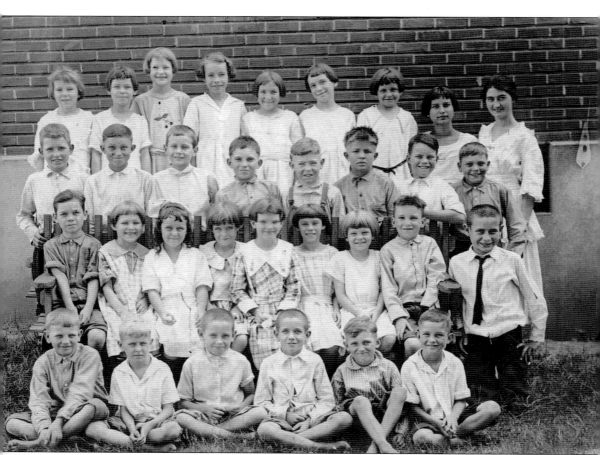

Cordova School third and fourth graders are seen here in 1922. Pictured are, from left to right, (first row) Allen La Croix, Gerald Ellis, Charles Rast, W.B. Rast, and two unidentified Sorrell children; (second row) Billy Mullins, Margaret Morton, Louise Marlow, Doris Strong, Hazel Summers, Frances Bazemore, Louise Weaks, Henry Davis, and Thomas Rast; (third row) Bert Perry, James Callicutt, Norman Ellis, Alvin Dozier, Franklin James, Cecil Coulter, Lonnie Bryan, and Marvin La Croix; (fourth row) Frances Mullins, unidentified, Elma Rogers, Mildred Rutledge, Bessie Morgan, unidentified, Hazel Perry, Ada Callicutt, and teacher Patty Fletcher. (Courtesy of Carolyn Bazemore.)

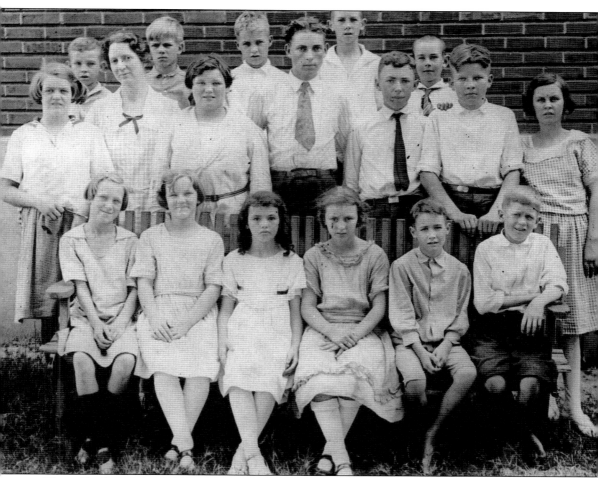

These Cordova School fifth and sixth graders are pictured in 1922. They are, from left to right, Rebecca Morton, Birdie Humphreys, Lula Hooker, unidentified, Leonard Rogers, and Edward Humphreys; (second row) Martha Humphreys, Effie Weaks, Grace LaCroix, Elzie Smith, Sidney Hall, Joe Rogers, and Florence Crook; (third row) Carter Pierce, unidentified, John Pierce, Malcolm Rogers, and Clyde "Gus" Yates. (Courtesy of Carolyn Bazemore.)

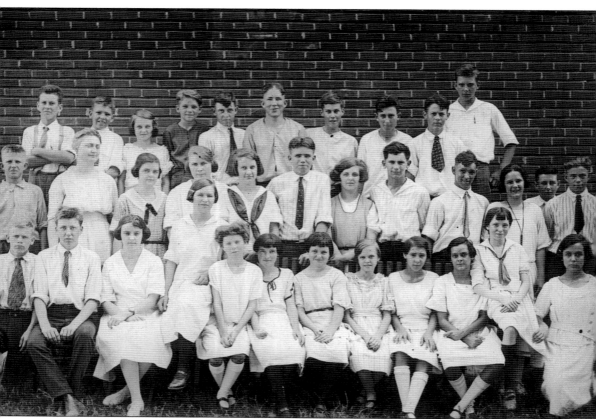

This photograph shows the Cordova School seventh and eighth graders of 1922. Pictured are, from left to right, (first row) Charles A. Humphreys, Glenn Weaks, home economics teacher Louise Callis, Nina May Morton, Ruthie Mae James, Evie Callicutt, Beulah Callicutt, Grace Weaks, Earnestine Morton, Ellen Latting, Lorena Weaks, and Emma Lou Latting; (second row) Herman Coulter, principal and math/Latin teacher Sally Fletcher, English teacher Margaret Boyce, Susie Mae Bazemore, Mary Rogers, Charles E. Humphreys, Sarah Ellis, Clinton Moore, Phares Abraham Morton, Helen Neely, Milton Thompson, and Ecklin Feild; (third row) Franklin Yates, James Summers, Mildred Reinbold, Boyd Patrick, J. Carl Humphreys, Charles "Boots" Bowers, Francis Hillon, Monroe Reinbold, Clinton Humphreys, and Harry Summers. (Courtesy of Carolyn Bazemore.)

The 1930 boys' basketball team consisted of, from left to right, (first row) unidentified, Henry Davis, Jimmy Yates, James Houston, and Clyde Allen "Gus" Yates Jr.; (second row) unidentified, coach Maurice Moore, Bert Perry, Leonard Rogers, and Francis Schwaiger. (Courtesy of Cordova Museum.)

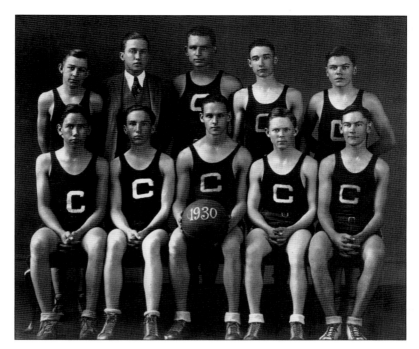

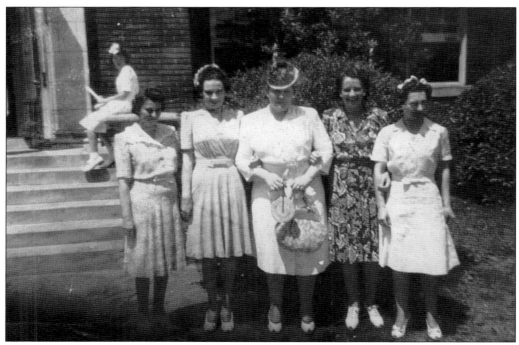

In this image, Cordova teachers pose with Shelby County school superintendent Dr. Sue Powers. They are, from left to right, Eddie Humphreys, Laverne Saunders, Dr. Sue Powers, Mary Rogers Bazemore, and Abbie Howard. This was taken between the years 1940 and 1942. (Courtesy of Sarah Hall Bowlan.)

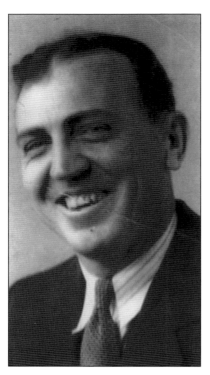

Charles Herbert Harrell (1898–1984) was born in Arlington, Tennessee. He attended college at Mississippi State University and went on to become principal at numerous schools, including Bolton, Cordova, Collierville, Whitehaven, and Grays Elementary. After retirement, he became headmaster of Whitehaven Presbyterian School. (Courtesy of Norma Schwam Miles.)

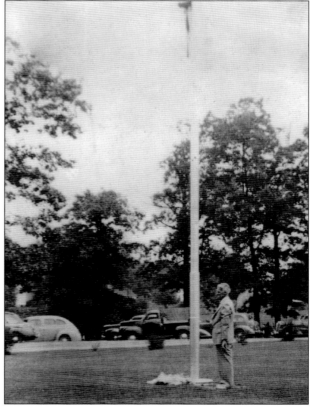

PTA president and music teacher Irene Prichard, mother of Norma Prichard Rogers, heard that the Peabody Hotel in Memphis was replacing its flagpole. The Peabody agreed to give the pole if the school arranged pickup. The flagpole was dedicated May 30, 1941, in memory of Edward Otto Schwam, who served in World War I. Cordova postmaster Joe Arrington raised the flag at dedication. (Courtesy of Cordova Museum.)

Four

BUSINESSES

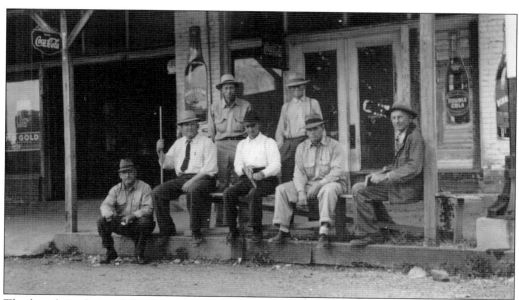

The bench in front of the Yates General Merchandise Store was named the "Buzzards Roost" because this is where the men would gather to discuss their gardens and other topics of interest. Yates's store was also a pool hall and barbershop. Pictured here are, from left to right, owner Grover Yates, Preston Yates, Tommy Sanderlin, Rogers Humphreys, and Claud Rogers; (second row) Terrell Hall and Luther Weaks. (Courtesy of Carolyn Bazemore.)

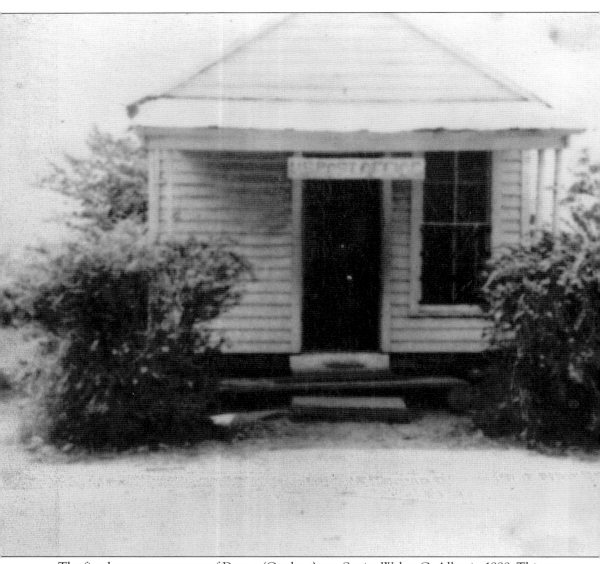

The first known postmaster of Dexter (Cordova) was Squire Walter G. Allen in 1888. This one-room structure, located on the south side of Macon near the present train station, was declared a federal post office on March 13, 1900. Etta Allen, daughter of Walter "Watt" Clopton Allen and Amanda Williams, became the first postmistress and held that position for 40 years. In 1922, Raymond Morton became the first rural mail carrier, with a route covering 85 miles round trip. He retired in 1956 after 34 years of service. In 1938, a brick post office was erected where the old post office had stood, and the original structure was moved to Phares Morton's place, where it now resides behind the Cordova Community Center. In 1955, a larger, brick post office was built on B Street. The present Cordova Post Office opened on Macon Road near Germantown Parkway on November 13, 1988. (Courtesy of Cordova Museum.)

In 1888, the Tennessee Midland Railroad came through this area, providing economic growth and means for transportation. The Cordova Railroad Train Depot was built in 1889 on the west side of B Street. Stationmaster George Y. Jones oversaw the freight, passenger cars, and mail. Years later, the Cordova Library was located here before moving to the Cordova Community Center. This depot is still standing in its original location. (Courtesy of Cordova Museum.)

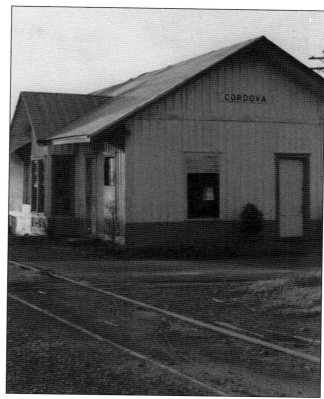

The Walter Granville Allen store stood on Macon Road in what is now an empty lot beside the Cordova Bank & Trust building. It went through several owners and name changes, including Farley, Anderson, and Bowers. (Courtesy of Kathryn Bowers.)

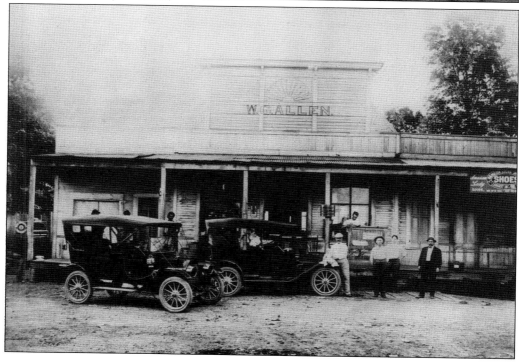

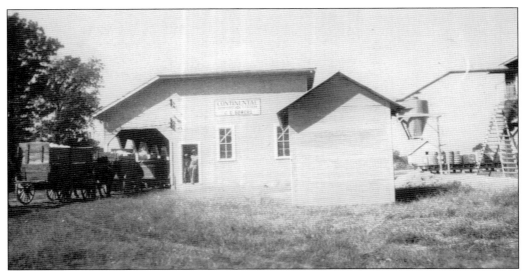

The early settlers brought their personal cotton gins with them in the 1830s. The Allen family built the first advanced commercial cotton gin in the early 1900s. Located south of Macon Road and east of Blake Road, it was powered by a steam engine and was destroyed by a fire. The Bowers family built a new electric-powered cotton gin north of Macon Road behind the Yates General Merchandise Store in the center of the business district (above and below). At the end of the 1930s, the US Department of Agriculture initiated a program under the direction of Amelia Stanton, Shelby County agent. During the month of September, at the height of the ginning season when lint cotton was plentiful, Stanton would supervise families as they made their own mattresses. The Department of Agriculture furnished the cloth ticking, heavy string, and needles. (Both courtesy of Kathryn Bowers.)

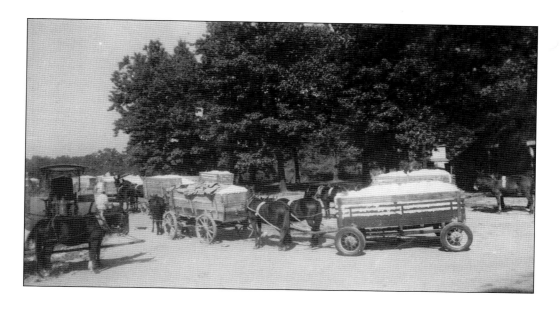

Farmers picked cotton by hand and carried it to the gin by wagon. The line at the gin could take a while, so they visited while they waited. Once they got to the gin, the wagons proceeded in single file where the ginning process began, as seen above. The cotton was vacuumed from the wagons by equipment that would then clean the fibers of seed, limbs, leaves, and dirt. Once the cotton finished with the ginning process, it was compressed into a bale. The lint was held together by eight steel straps and was wrapped for protection. Each bale weighed approximately 500 pounds. The bales were then loaded and carried to market, as seen below. Prices were determined by experts from samples taken from each bale. (Both courtesy of Kathryn Bowers.)

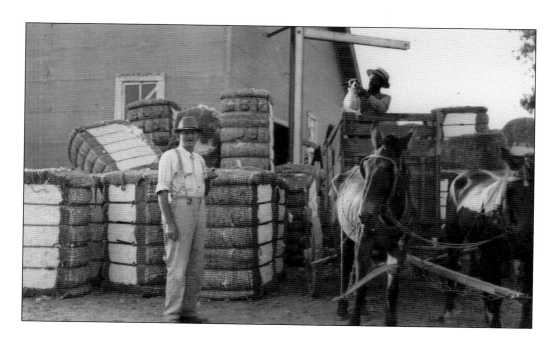

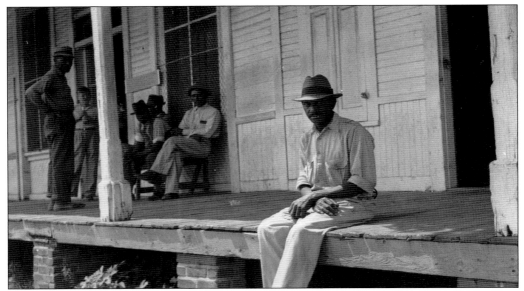

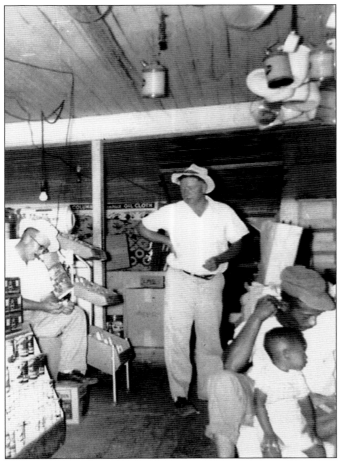

General country stores were erected as conveniences when it was hard to travel by wagon to larger towns for commodities. This type of store became a part of the social life of the community, with stovepipe wood heaters welcoming visitors to stay and perhaps play a game of checkers while they smoked their pipes. When electricity was installed, the stores offered fresh and frozen meat. Above is probably the W.G. Allen Store. At left is the Godwin Store at Pisgah and Macon Roads, run by Fred and Lillie Mae Bain Godwin for many years. Lillie Mae also worked in the Cordova and Eads Post Offices until she retired in the 1980s. Fred was the son of Eli Jefferson Godwin and Mary Josephine Hooker Godwin. (Above, courtesy of Kathryn Bowers; left, courtesy of Billy Bain.)

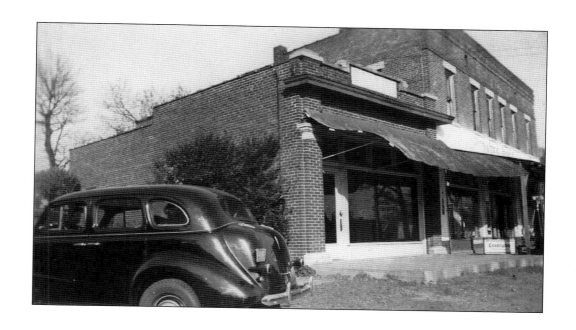

Above, the first building to the right of the car was used as the Cordova Gin office. It was also the Cordova Bank & Trust building. The bank closed in 1937. Beside it was the Yates store. Below, the Anderson & Bowers General Merchandise store sat to the left of the bank building. There was a space between the buildings to provide access to the Cotton Gin, which sat behind the bank and the Yates store. Anderson & Bowers, which was originally the W.G. Allen Store, burned and remains a vacant lot today. (Both courtesy of Kathryn Bowers.)

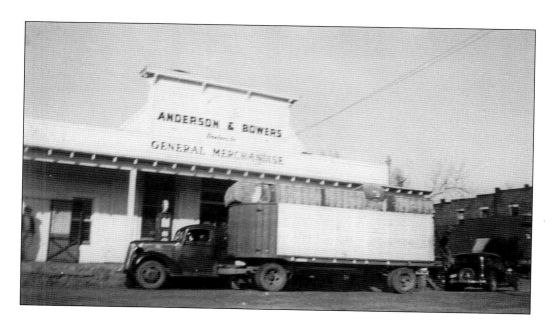

Dr. Clarence Alvy Chaffee came to Cordova in 1919. His clinic was located next door to his home on Macon Road. The clinic had two entrances, one for white patients and one for black patients. Dr. John Thomas Carter practiced with Chaffee for a while before moving to Germantown, and he married Chaffee's niece Lenora Chaffee. The redbrick clinic was later covered with white stucco and was eventually torn down in 1992. Many of the original items used in Chaffee's clinic were donated to the Cordova Museum by his son Clarence Jr. (Both courtesy of Kathryn Bowers.)

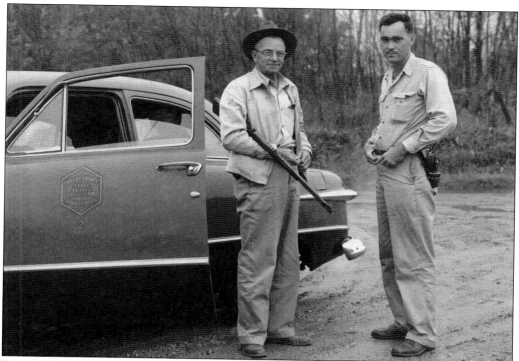

Pictured above are penal farm manager Thomas Eugene Hooker and guard Charles Miller Arguitt Jr. Hooker (1891–1989) was the son of William Augustus "Dick" and Elizabeth "Bettie" Lewis Hooker from Fisherville, and was a blacksmith by trade. He began his life's work in the penal system in 1912 at the Shelby County Workhouse in Memphis. Later he became manager of the Shelby County Penal Farm after it moved to Cordova. Hooker and his wife, Thelma Murphy Hooker, lived on the farm in a comfortable brick home and raised their three children there. He was a tough corrections officer and led many a manhunt for escaped prisoners. He ferried prisoners to and from nearby states for incarcerations or to court hearings, and none escaped. The farm posted a sign that read, "A self-supporting farm." The inmates planted and harvested the crops and took care of the cattle, pigs, and chickens, among other responsibilities, until 1964. Below, trustees are pictured with guard C.M. Arguitt Jr. as the dogs are readied for a manhunt in 1953. (Both courtesy of University of Memphis.)

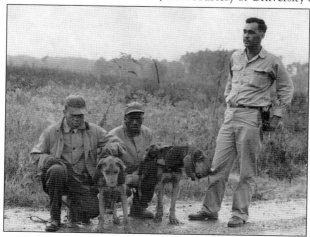

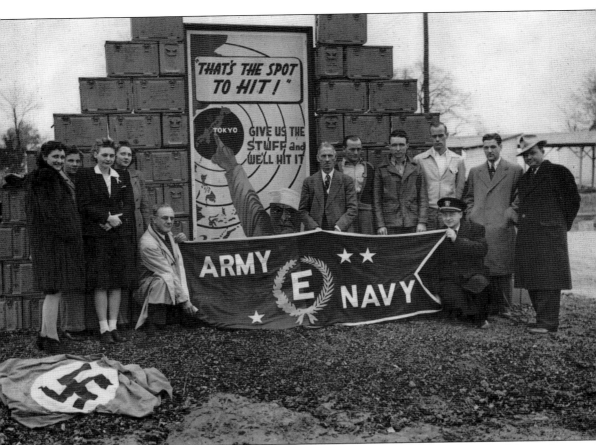

In 1941, the National Fireworks Company purchased approximately 500 acres of farmland, located south of Macon Road near Lenow Road, from the John Henry Schwam family. This company—the first industry to be located in Cordova—made ammunition during World War II for the Army and Navy, from 1941 to 1945. They produced 20- and 40- millimeter shells, smoke pots, and incendiary bombs. Many employees of the plant came from Cordova and neighboring communities. The plant won five excellence awards from the War Department. Some of the National Fireworks building is still in existence today and is used by several small industries. Pictured above at the fourth award ceremony are, from left to right, Rosemary Hammond, Lou Wanna Nickelson, Margaret Schwam, Mary Baird, Ed H. Luce, Lee Schmitt of the US Navy, G.W. Robinson, Robert Lemmons, James Garner, G.C. Hale, Leland L. McGraw, and C. Winston Churchill. The photograph was taken at West Gate, Plant No. 6, on December 7, 1944. (Courtesy of Cordova Museum.)

Five

CHURCHES
AND CEMETERIES

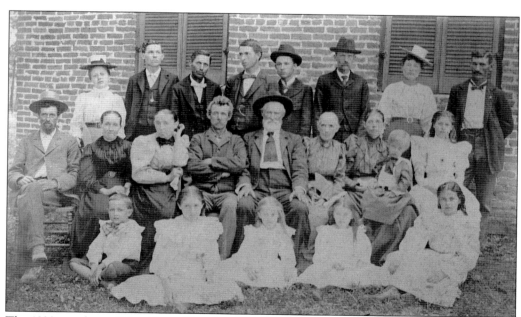

The 1898 members of New Hope Church at Sangie pictured here are, from left to right, (first row) Robert Sydney Ellis, Rosa Ellis Rayl, Ora Ethel Carter, Mary Sadie Carter, and Lottie Leola Carter Pierce; (second row) James E. Weaks, Ellen Carter Weaks, Tennessee Owen Carter, John Wesley Carter, Christopher Columbus Owen, Polly Ann Owen, Tennessee Virginia Owen Carter, Walter Bryan Carter, and Julia Beatrice Carter Houpe; (third row) Virgie Gertrude Weaks, minister David Alvin Ellis, Jessie Everett Ellis, teacher Ernest Bunyan Ellis, Jessie Everett Ellis Jr., John Owen, Sarah Owen Bazemore, and Jesse Edward Bazemore. (Courtesy of John Edward Pierce Jr.)

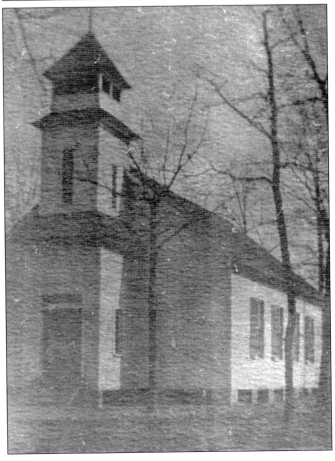

The first Baptist church in the area was organized in 1866, with 18 charter members meeting in a log schoolhouse. In 1876, work began on a church building that was dedicated in 1878. The church, known as New Hope Baptist, sat at present-day Sanga and Walnut Grove Roads. It was built of handmade brick. When the brick church burned, a wooden clapboard building (above) was built around 1900. Note the one-room schoolhouse in the background to the right. Sangie Cemetery is at this location. At left, members decided in 1896 to build a church in Cordova at the present location of Macon and Sanga Roads. Members provided the labor, and by Christmas the building was completed. It burned in 1925. (Both courtesy of Cordova Museum.)

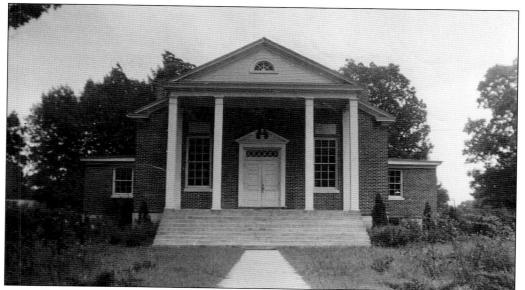

The Cordova Baptist Church members began a new building program, with members again providing the labor. A basement was built and roofed, and services began to be held in the basement in 1926. Between 1938 and 1943, the present brick sanctuary, pictured here, was completed. (Courtesy of Flynn and Virginia Morton.)

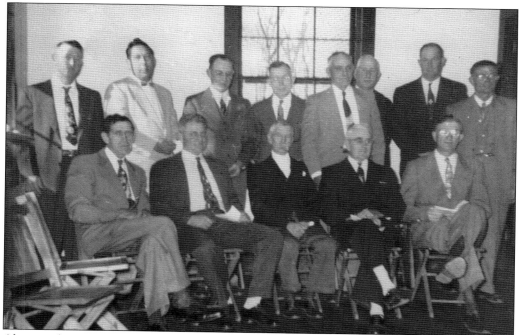

Above is the men's Sunday school class at Cordova Baptist Church, photographed in 1950. The members are, from left to right, (first row) William Joseph Strong, James Edward Barber Sr., unidentified, Reginald M. Houpe, and George Y. Jones; (second row) unidentified, ? Sparkman, William Riley, Luther Flowers, Grover Yates, Malcolm Rogers, ? Joyner, and James Harris Nichols. (Courtesy of Elizabeth Virginia Nichols Griffin.)

Beginning in 1949 and the early 1950s, Shelby County Baptist Church purchased and developed a little over 100 acres in the small, rural community of Cordova, just outside of the Memphis city limits. It was a perfect place for a church camp: easy to get to and only an hour's drive from most of the association's churches. Camp Cordova served as an easy getaway for retreats, picnics, and outings. (Both courtesy of Yvonne Baker.)

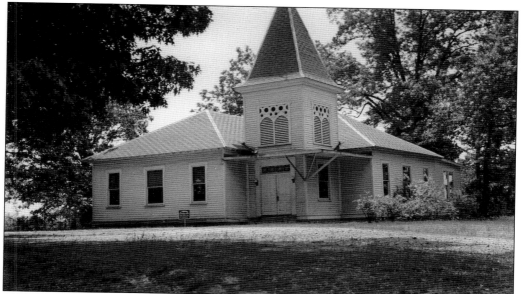

The first Presbyterian church was erected in 1891 and burned in 1911. The cornerstone to rebuild was laid in 1912. When Charlotte "Lottie" Humphreys (widow of Charles A. Humphreys) died, she left money to the Presbyterian church, of which they had been members. The building, seen here, was torn down, and construction of a new church began in 2012. Lottie Humphreys was the daughter of Charles Augustus Murphy and Betty Goodman Murphy. (Courtesy of Kathryn Bowers.)

The Cordova Presbyterian Women's Missionary Society included Carrie Rogers (mother of Mary Rogers Bazemore), Gladys McCormack, Bernie Yates, Gertrude Moore, Ruth Humphreys (in rocker), and Annie Bell Gracy Wheeler (wife of Rev. William Leonidas Wheeler). (Courtesy of Norma Schwam Miles.)

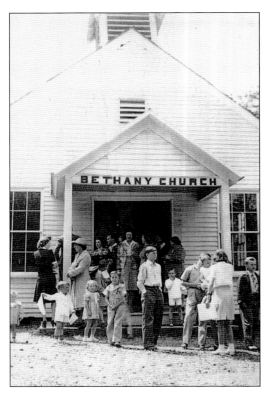

Bethany Christian Union Church was founded in 1838 by Matthew Webber. The parish shared the pulpit with other denominations until other area churches were built. The church and graveyard were located on 10 acres owned by William Hamner Jr. and Elizabeth Blain Hamner. Hamner, from Albemarle, Virginia, was the first schoolmaster in the church school. After the Civil War, his son James and James's wife, Mary Hooker Hamner, sold the property to the church in 1872 for $90. In 1889, the official name of the parish became Bethany Christian Church (Disciples of Christ). Below, Viola James, Myrtie McNeely, Elmo Bryan, Ada James, and Florence Powell stand in front of old Bethany Christian Church at the dedication ceremony of the new building. They were lifelong members of this church. (Both courtesy of Bethany Christian Church.)

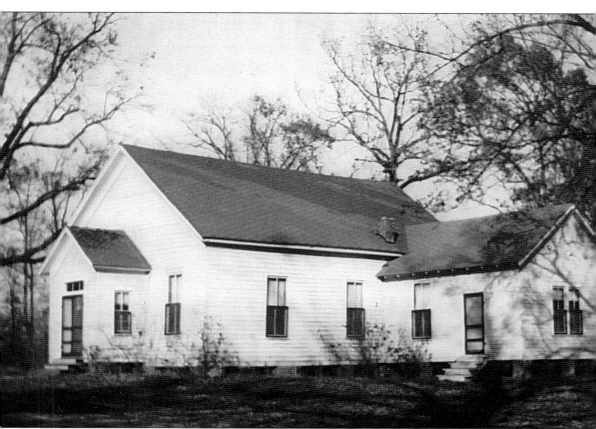

Morning Sun Cumberland Presbyterian Church is known as the "the little church in the woods." It sits off Highway 64 on Morning Sun Road, very serenely tucked away in the woods. This church was first organized around 1830 as the Green Bottom Cumberland Presbyterian Church. Later, it combined with another small Presbyterian church and became known as Morning Sun. This parish has held an annual barbecue homecoming event for many years that is open to the community. A cemetery established across the street from the church in 1852 is where many of the early settlers of Cordova are buried. In 1862, there was a Civil War skirmish at the intersection of Stage (Highway 64) and Morning Sun Roads, known today as the Battle of Morning Sun. The graves of 12 unidentified soldiers from this battle are located near the back of the cemetery. (Courtesy of Debbie Patrick Roe.)

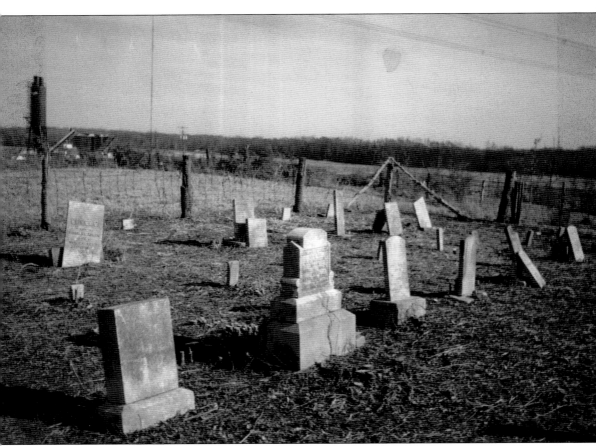

The Allen Cemetery, located on the Thomas Allen home place on the south side of Macon Road at Berryhill, includes many Yates relatives. The oldest marked grave in this cemetery is that of Thomas Allen, dated January 16, 1848. The last person buried there, William Henry Yates, died on November 10, 1934. Other local cemeteries of comparable age include Sangie Cemetery, Redditt Cemetery, Bethany Cemetery, Morning Grove, Morning Chapel, Marks-Tate Cemetery, Cordova Community Cemetery, and others. (Courtesy of Norma Schwam Miles.)

Six

MILITARY VETERANS

Thomas Walter Yates lost an arm in the Civil War. He was the second schoolteacher at Cordova School, after Gussie Allen. He was said to be a strict teacher, making up in determination what he lacked in patience, and many a lagging brain picked up considerable knowledge when confronted by his threats. He was the son of Thomas Varden Yates and Jamesey Allen Yates, grandson of Thomas and Becky Ecklin Allen. He married Mattie Tate. (Courtesy of Cordova Museum.)

Julius Lycirgus Strong (1844–1914) was a Civil War soldier from the Cordova area. His grandson Joseph Clayton was born in his house in 1932. Julius married Mary "Mollie" Duvall in 1868 in Memphis, and they are buried in Old Bethany Cemetery. Grandson Joe's parents were Earl Anderson and Annie Strong Clayton. (Courtesy of Joseph A. Clayton.)

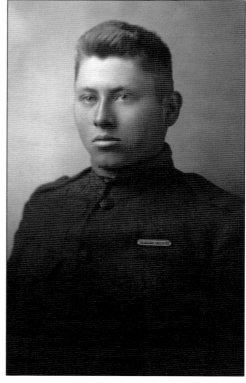

John Talmage Burrows ate lots of bananas to gain enough weight to join the Marines during World War I. He lived in Cordova from age three until he married Mary Humphreys Burrows at age 26 in 1926, then lived in Memphis and Germantown. He and Mary had two sons: John Talmage Burrows Jr. and Harold Gene Burrows. Both John and his brother Sidney worked for the Post Office Department at the main post office in Memphis from shortly after World War I until their retirement. (Courtesy of John Talmage Burrows Jr.)

This 1918 photograph is of Earl Humphreys in World War I. Humphreys was one of the first three students to graduate from the new Cordova High School in 1914, which at that time went to 10th grade. He and two other classmates were distinguished as the first graduates from Cordova and as double graduates, as they returned the following year to complete the newly added 11th grade. (Courtesy of Cordova Museum.)

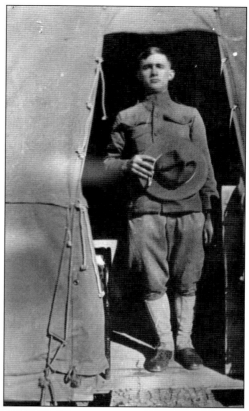

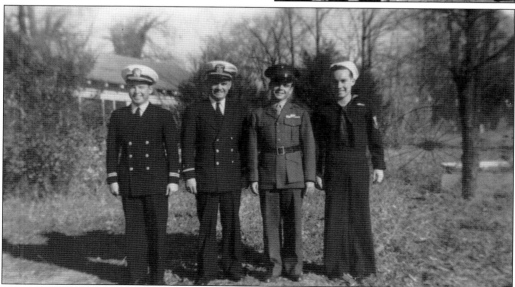

Two of the Yarbrough girls married two of the Mullins boys from Cordova. Their children all joined the armed services during World War II. Phillip Mullins (far left), son of Thomas Phillip and Bettie Luella Mullins, stands with his cousins (from left to right) Billy, Julian, and David Mullins, sons of Guy and Effie Mai Mullins. (Courtesy of Nancy McDaniel.)

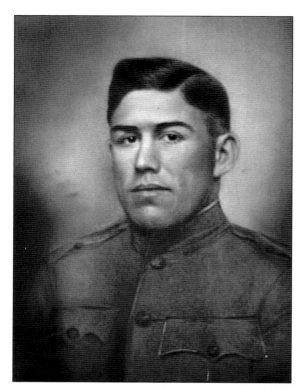

Former Cordova student Edward Otto Schwam Sr. (1896–1931) served in the Army during World War I. The flagpole donated by the Memphis Peabody Hotel was dedicated in his memory in 1941. His parents were John Henry and Lula Tucker Schwam. Otto married Lois Elizabeth Sawyer. (Courtesy of Norma Schwam Miles.)

James Austin Baker, USS *West Virginia* first class electrician's mate, was at Pearl Harbor on December 7, 1941. A telegram was sent to his father nine days later, December 16, reporting that James had been killed in action. An obituary ran in the *Memphis Press-Scimitar*. Baker's father was notified on December 21, by telegram, that his son was still alive. Baker later became the president of the Memphis chapter of Pearl Harbor Survivors. (Courtesy of Yvonne Baker.)

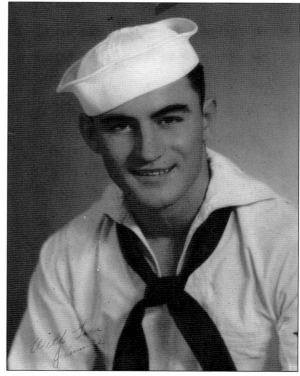

Samuel Gordon Bazemore Sr. married Doris Evelyn Shambley, from Memphis. In addition to farming, Gordon was the postmaster in Cordova for many years. He and Doris are buried in Cordova Community Cemetery. (Courtesy of David Bazemore.)

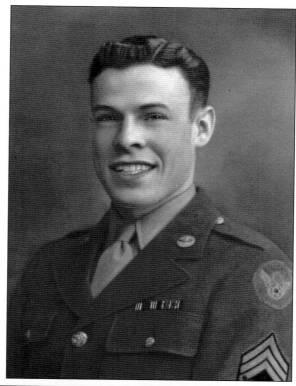

Marvin Christopher Bazemore is pictured with his wife, Mary Rogers Bazemore, on their wedding day in 1942. He served in the US Army as a military policeman stationed in Georgia during World War II. After service, he worked at the Shelby County Penal Farm. Mary Rogers Bazemore was a Cordova schoolteacher. Marvin was the son of Jesse Edward Bazemore and Sarah Owen Bazemore. (Courtesy of Jo Hall.)

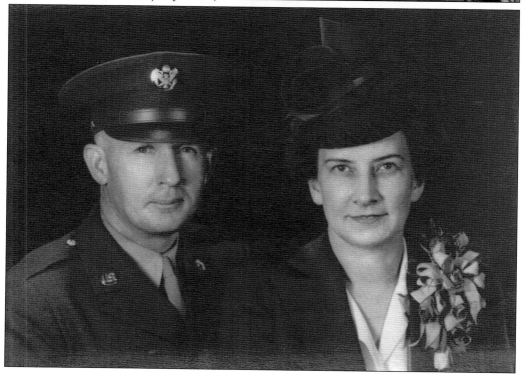

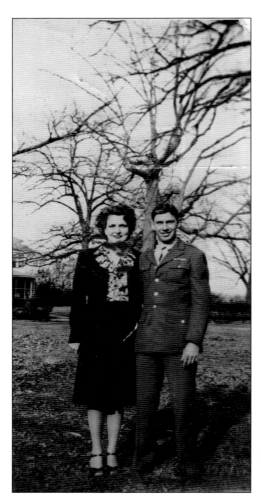

James Bazemore was killed in World War II when he stepped on a land mine just a short time before the war was over. Here, he is standing with sister-in-law Doris Bazemore. (Courtesy of David Bazemore.)

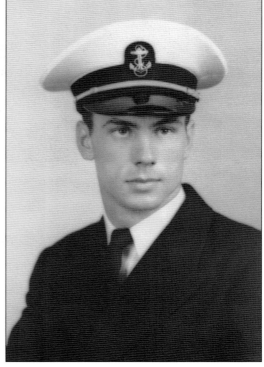

William Stevenson Bledsoe Sr. was a pilot in World War II. After the war, he became a doctor of dental surgery and was a pioneer in diagnosing and treating temporomandibular joint disorders (TMJ). He was one of the original nine citizens who purchased the old Cordova School building and formed the nonprofit Cordova Community Center. (Courtesy of Dr. Steve Bledsoe Jr.)

Charles Edward Bowers Jr. was known as "Boots" Bowers to all of his friends. The Bowers family owned the Cordova Gin Company. Boots was drafted into the US Army at the age of 36. He was mechanically inclined and enjoyed working and tinkering with automobiles in the backyard, at the garage where he worked, and for the Army. He received an honorable hardship discharge to return home and run the gin company when his father's health declined. (Courtesy of Kathryn Bowers.)

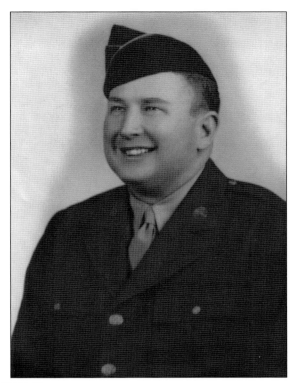

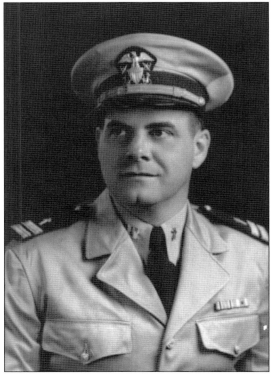

Chaplain Flynn G. Humphreys, son of Joseph and Betty Irwin Humphreys, was born in Cordova. He was a pastor in Huntsville, Alabama, before entering the US Navy as a chaplain in 1942. He served in nine major engagements in the Pacific, later served in the veteran's hospital, and retired as a captain in the Navy Reserve. (Courtesy of Flynn and Virginia Morton.)

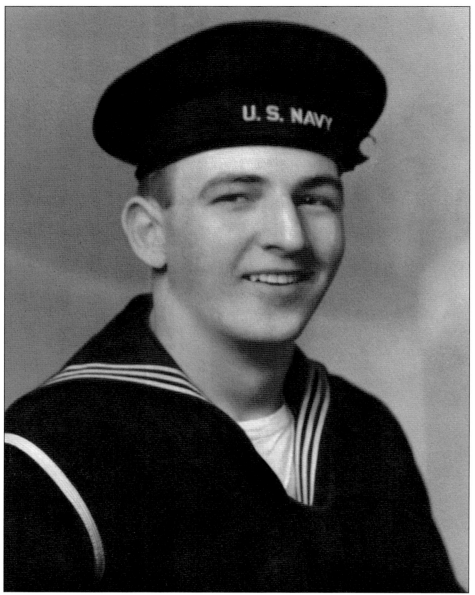

John Lawrence Garrison Jr. was born on a farm in the Cordova area. He attended Cordova School and Germantown High School and was certified and licensed as an aircraft mechanic upon high school graduation. He enlisted in the Navy in 1943 and served three years as a naval gunner in World War II on the USS *New Jersey* (BB62). The *New Jersey* became the most highly decorated warship in naval history. Garrison was in 11 major invasions. After being honorably discharged in 1946, he was employed as a mechanical draftsman for 12 years with Ford Motor Company, followed by 35 years of employment for the US Department of Defense, with 27 of those years being under high security clearance. He married Velis Bartelozzi, a first-generation Italian American. Velis was educated in Italy during the rule of fascist dictator Benito Mussolini. Being antifascist, she fled to the Alps and became a spy for the United States with the call name of "Radio Velis." (Courtesy of John L. Garrison Jr.)

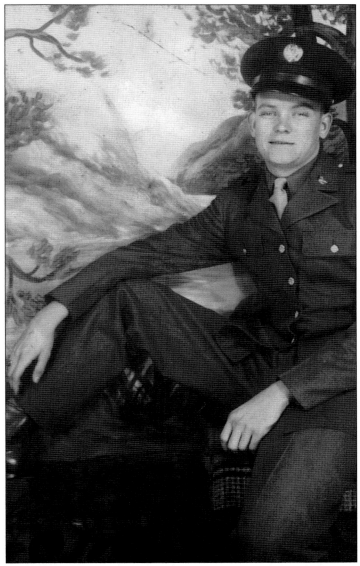

Col. William "Bill" Patterson Hooker, son of Newton Payne and Sallie Ethel Nolen Hooker, entered the Army at age 17 and graduated from the Infantry Officers Candidate School at age 19. He was inducted into the Infantry Hall of Fame in 1970. His overseas assignments have included service in Japan, Korea, Iran, and the Republic of South Vietnam. He received his bachelor of science degree from the University of Omaha in 1960 and also graduated from Army Engineering School, the Ordnance Guided Missile School, the Command and General Staff College, and the War College. His decorations include the Legion of Merit with two Oak Leaf Clusters, the Bronze Star, and the Army Commendation Medal with three Oak Leaf Clusters. He also served as commander of the Pueblo Army Depot, Colorado, and commander of the US Army Material Command, Taiwan Material Agency. Hooker is married to Myra Turner Hooker and has four daughters. These families are longtime members of Cordova Baptist Church. His sister Oneida Hooker Orders, wife of Don Orders, taught at Cordova School for many years. (Courtesy of William Patterson Hooker.)

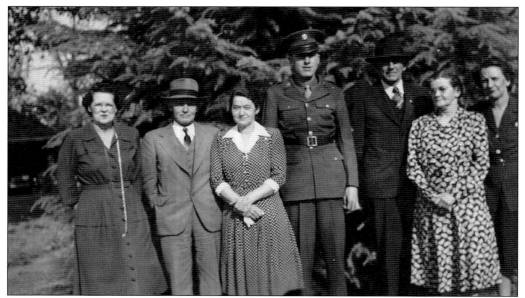

In this 1942 photograph, Carl Wilson Rogers (in uniform) stands with his parents, sister, aunts, and uncles. From left to right are Edna Brooks Lurry, Thomas Cleveland Lurry, Ollie Lydia Lurry, Carl Wilson Rogers, Claud "Buster" Rogers, Carrie Lurry Rogers, and Mary Rogers Bazemore. (Courtesy of Carolyn Bazemore.)

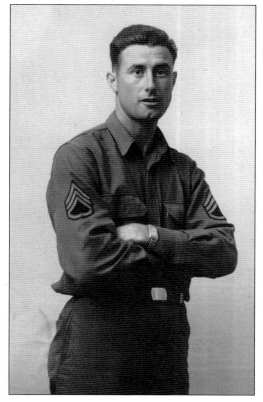

S.Sgt. Wesley Rogers was in Patton's 3rd Army 411 Antiaircraft Gun Battalion. He married Norma Prichard while stationed at Fort Eustis, Virginia, in 1942. Rogers was one of the original nine citizens who purchased the old Cordova School building and formed the nonprofit Cordova Community Center. (Courtesy of Norma Prichard Rogers.)

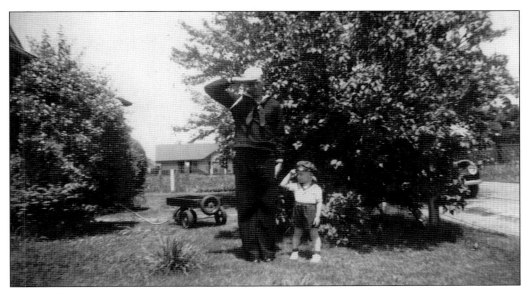

Oliver Malcolm Rogers served in the Navy. He is seen here teaching his young son Barry Malcolm Rogers how to salute. Note the little red wagon with the spare tire on back. The Cordova Train Depot is seen in the background. (Courtesy of Barry and Mary Rogers.)

Lt. John Schwaiger (1918–2008), son of Francis Joseph and Edith McCalla Schwaiger, attended Cordova School. He graduated from Memphis State College (University of Memphis) with a bachelor of science degree in 1940. After serving in the Army, he also received his master of arts degree from Memphis State University. He retired as a chemical storeroom supervisor. John married Alice Elizabeth "Beth" Ballenger, a Cordova School teacher. (Courtesy of Cordova Museum.)

James Howard Schwam was the son of John Henry Schwam and Jennie Lucinda Poston Schwam. He taught at Humes High School from 1940 to 1942 and was inducted into the Army in 1942. He served with the 12th Air Force P-47 Thunderbolt group in Italy and spent 26 months at various air fields in North Africa. (Courtesy of Cordova Museum.)

World War II veteran Henry Matthew "Jack" Yates was a farmer and school bus driver. He was loved by all the children who rode on his bus. He farmed cotton, soybeans, peanuts, pigs, cattle, and chickens. His father, Clyde Yates, drove one of the early school buses for Cordova School. (Courtesy of Linda Yates.)

From left to right, best friends Wallace Coulter, Johnnie Dan Rutledge, and Norman Bryan "Buddy" Hooker were leaving for the Army in 1941 at Union Station, Memphis, Tennessee. Buddy and Wallace attended Cordova School together, and Wallace's brother Herman Coulter married Buddy's sister Lula Hooker. Dan Rutledge married Buddy's sister Evangeline Hooker. Dan became a career soldier, serving in Korea and the Vietnam War before retiring from the Army after 26 years. Wallace and Buddy were killed in action in Germany. Wallace was in Patton's Army Tank Corps, and Buddy in the Army's 83rd and 104th Infantries. The graves of Buddy and Wallace are cared for by two young Hollanders, Stephan Geurts and Resi Pelen. They place flowers on the graves for special occasions, especially the men's birthdays. Buddy had two brothers who also fought in World War II: James Frederick "Jimmy" Hooker (father of author Darlene) and Joseph Clark "J.C." Hooker (husband of coauthor Jane). Another brother, John Robert "Bobby" Hooker, served during the Korean War. All of the Hooker family attended the old Cordova School, where Darlene and Jane now work. (Courtesy of Darlene Hooker Sawyer.)

About the Organization

Cordova Museum is a small museum located in Shelby County, Tennessee. It is located in the first permanent schoolhouse of this area, erected in 1913 by the prestigious firm Jones & Furbringer. The school closed in 1973 and was used for storage by Shelby County for the following 12 years. In 1985, after seeing a For Sale sign and fearing the building would be torn down, the citizens of the community purchased the structure and paid it off through various fundraising events over the next five years, forming the nonprofit 501[C](3) organization Cordova Community Center. With some of the items still remaining in the building, a museum evolved in one of the old classrooms with many of the school and town artifacts. In 1995, the building was added to the National Register of Historic Places.

Since the museum's founding, original school memorabilia has been on display in the museum room, including antique pupil desks with inkwells, teacher's desks, class pictures, a teacher's paddle, schoolbooks, student-written poems, sports and cheerleading uniforms, and more. Other relics that have been donated through time include items used by Dr. Clarence Chaffee in his clinic, a large collection of historical photographs and records, oral history interviews conducted in 1987 as part of a University of Memphis history department project, maps dating to 1888, 1896, and 1902 that show names of property owners, a train station bench from 1888, a horse-and-buggy lap throw, war ration stamps, an old steamer trunk, rotary telephones, early typewriters, and more. The museum is always interested in acquiring more items. However, because of space limitations, only objects that meet with the museum's mission to collect and preserve local area history can be accepted.

The back corner of the Cordova Museum has a media research area designated for family tree research. Here, a genealogist can access ancestry.com's library edition for free. The museum staff is ready to assist anyone who needs help or is unfamiliar in researching the online site or using the computer. Many times, the museum can assist the genealogists in finding photographs of ancestors who lived in and around Cordova.

Admission to Cordova Museum is free. Check the website at cordovacommunitycenter.com to verify days the museum is open in case of changes. Presently, the hours are 9:00 a.m. to 4:00 p.m. on Tuesdays and Thursdays and 9:00 a.m. to 2:00 p.m. on Saturdays.

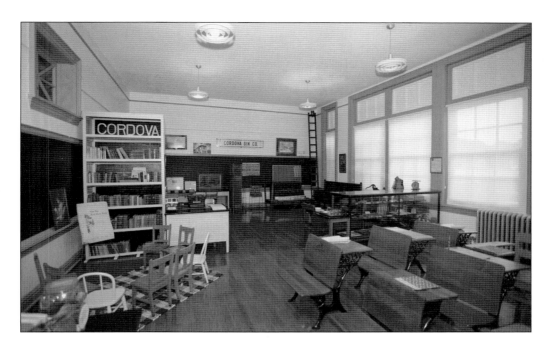

The Cordova Museum is located at 1017 North Sanga Road, Cordova, Tennessee, 38018. Below are historian and assistant director Dr. Jane Hooker (far left), volunteer and research assistant Donnie Hugh Odom (center), and curator and director Darlene Hooker Sawyer. (Above, courtesy of Becky and Harlan Stillions; below, courtesy of Cordova Museum.)

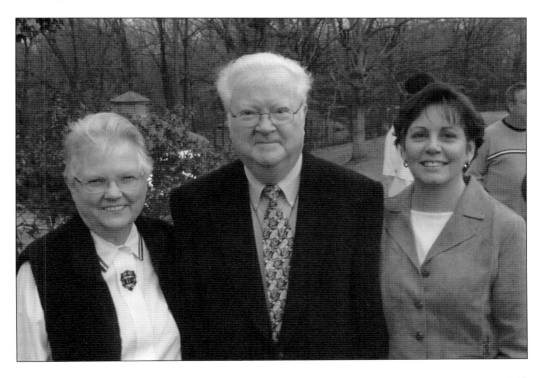

DISCOVER THOUSANDS OF LOCAL HISTORY BOOKS FEATURING MILLIONS OF VINTAGE IMAGES

Arcadia Publishing, the leading local history publisher in the United States, is committed to making history accessible and meaningful through publishing books that celebrate and preserve the heritage of America's people and places.

Find more books like this at
www.arcadiapublishing.com

Search for your hometown history, your old stomping grounds, and even your favorite sports team.